2

2

1

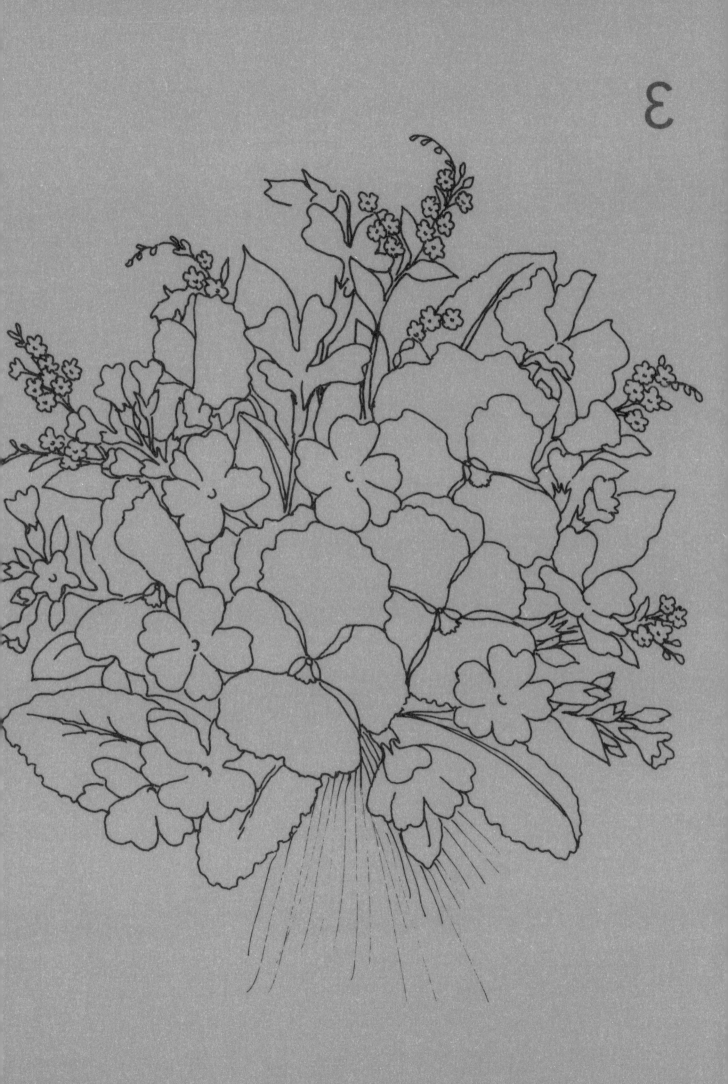

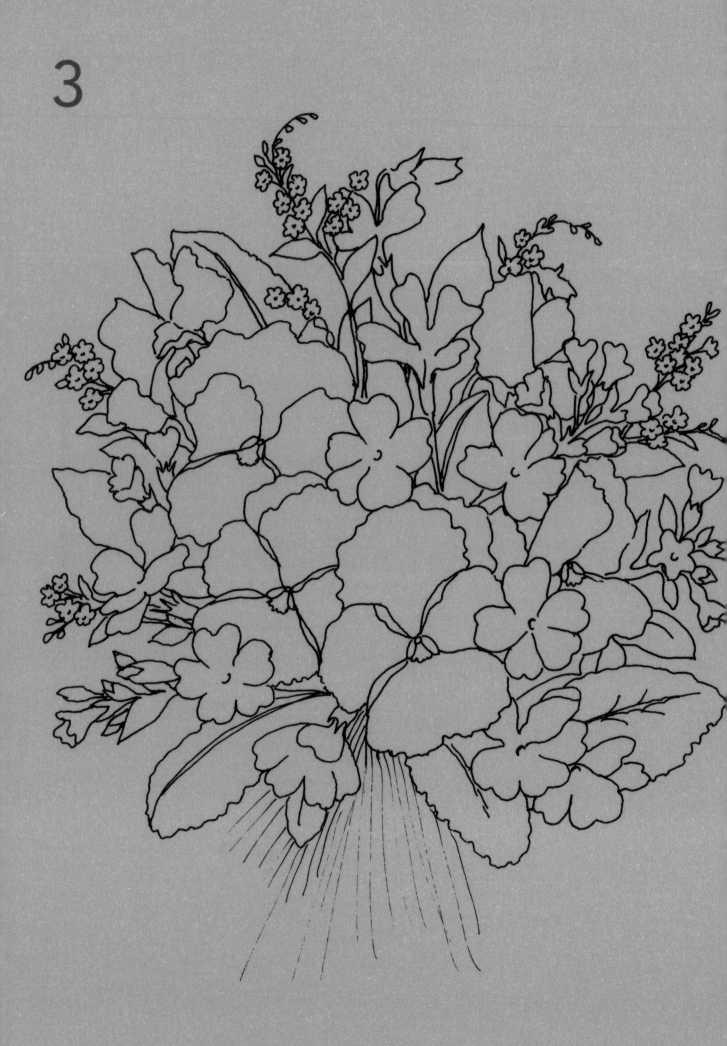

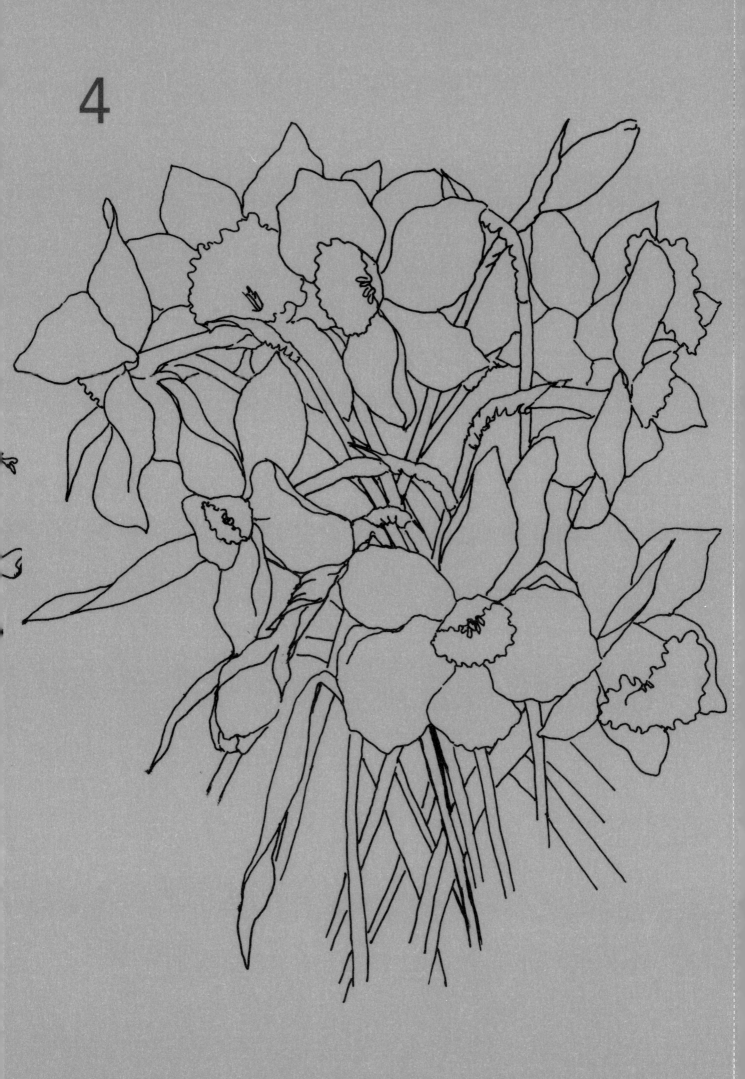

4

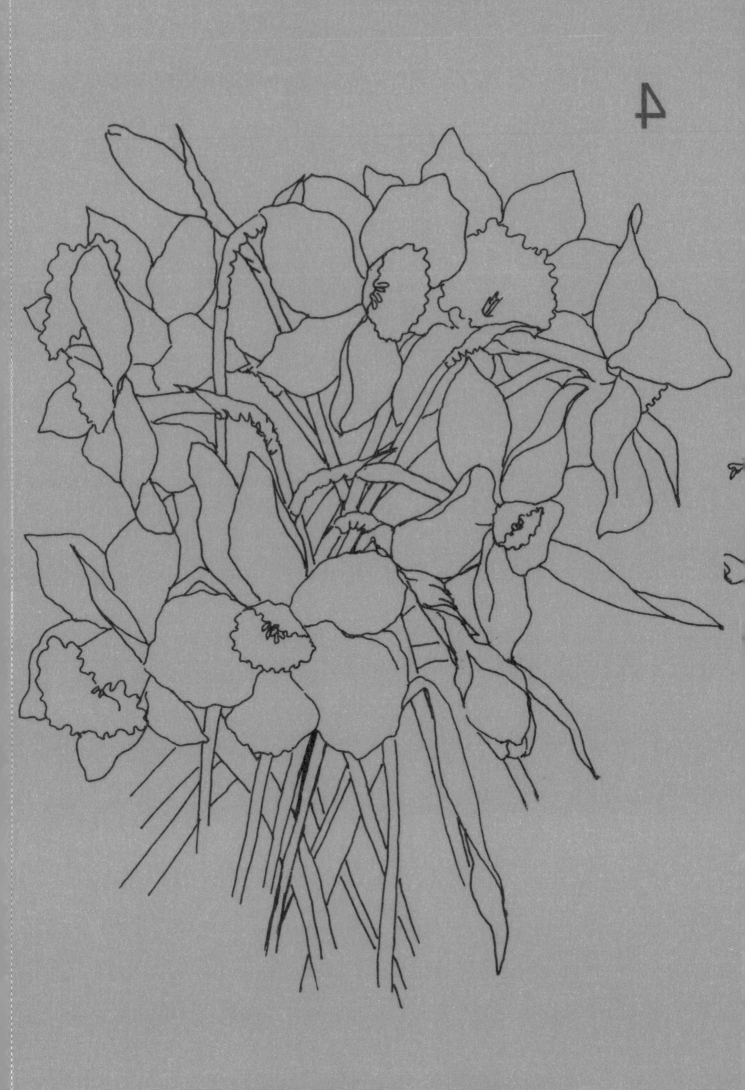

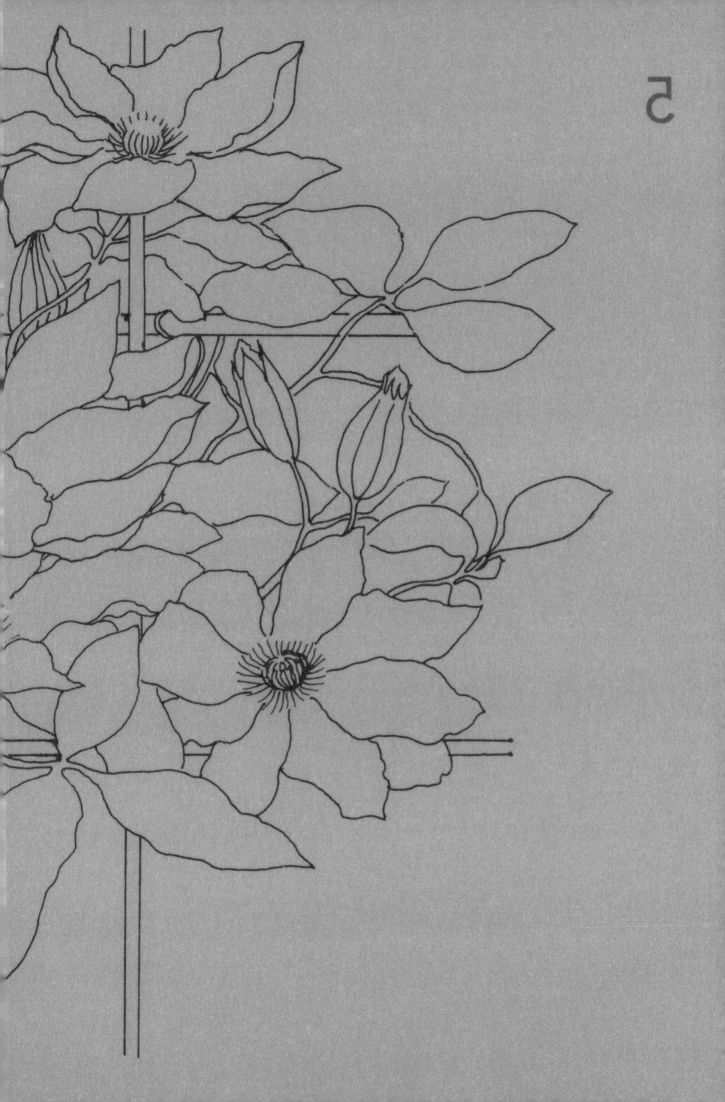

5

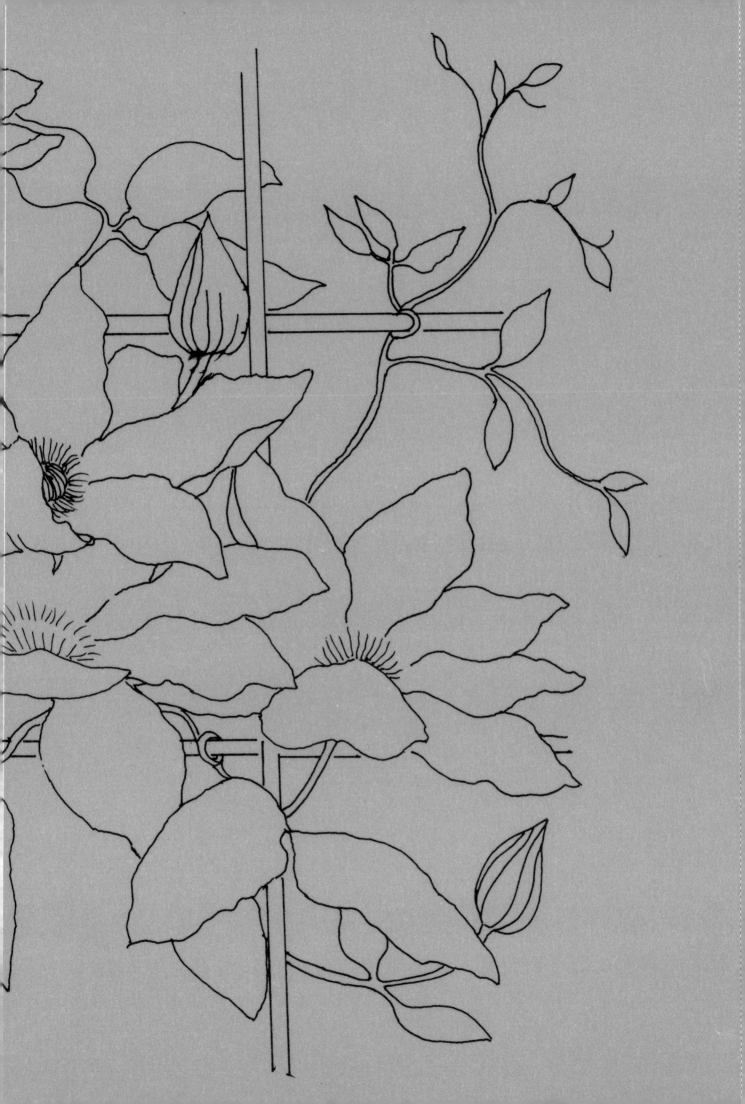

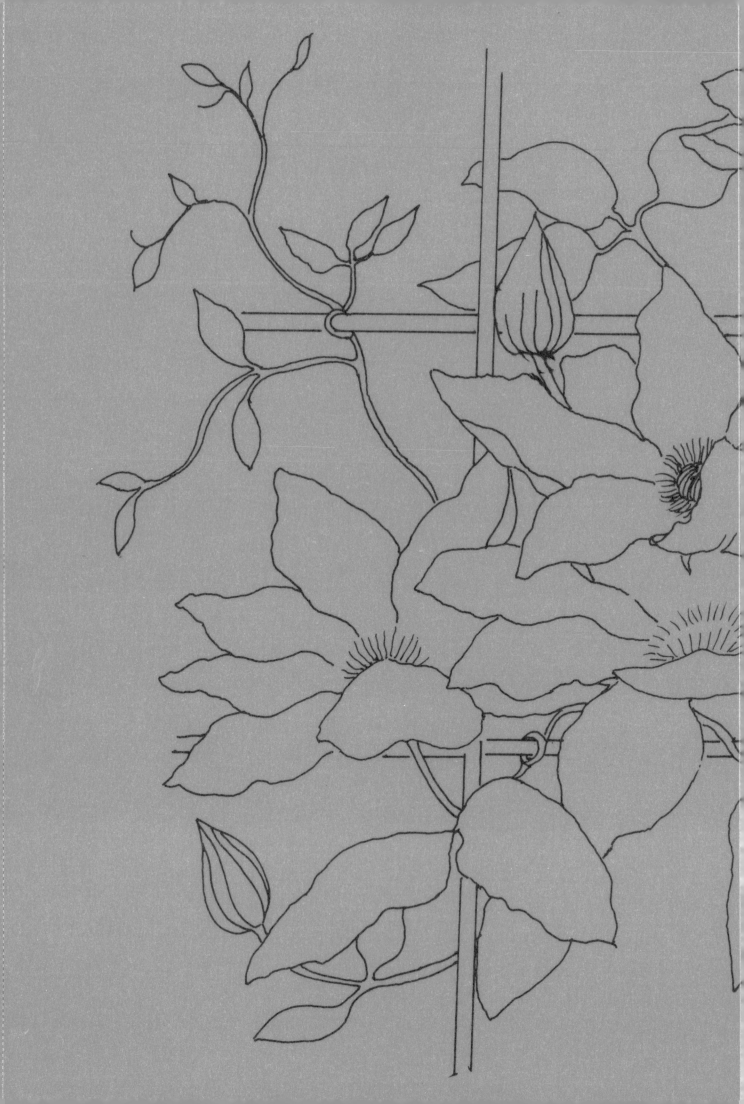

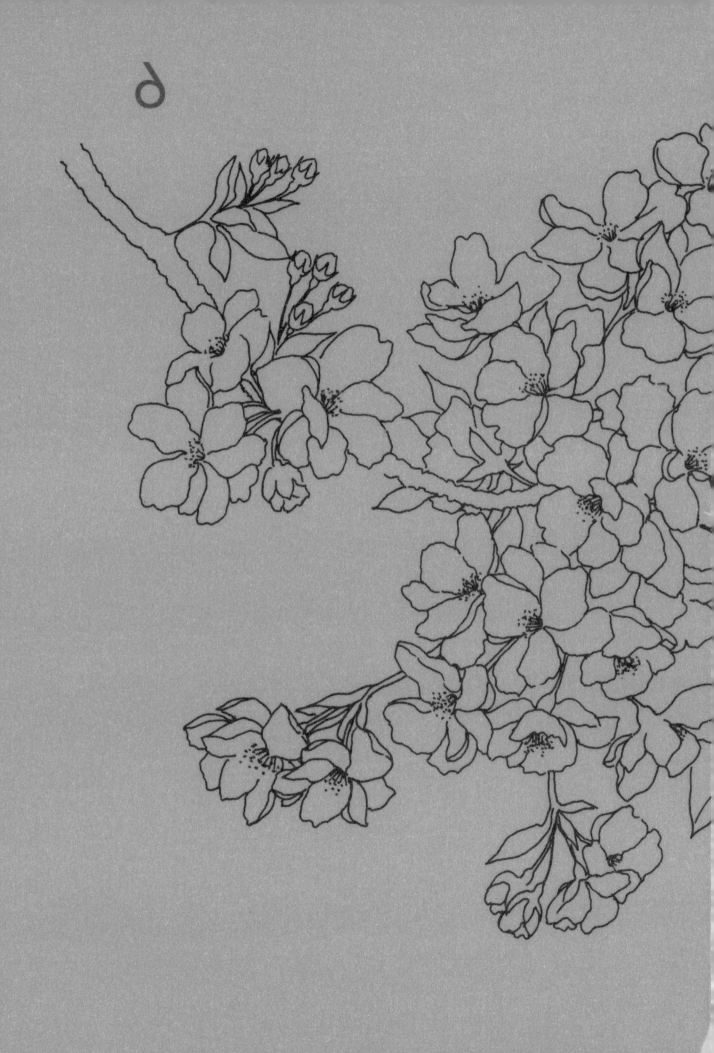

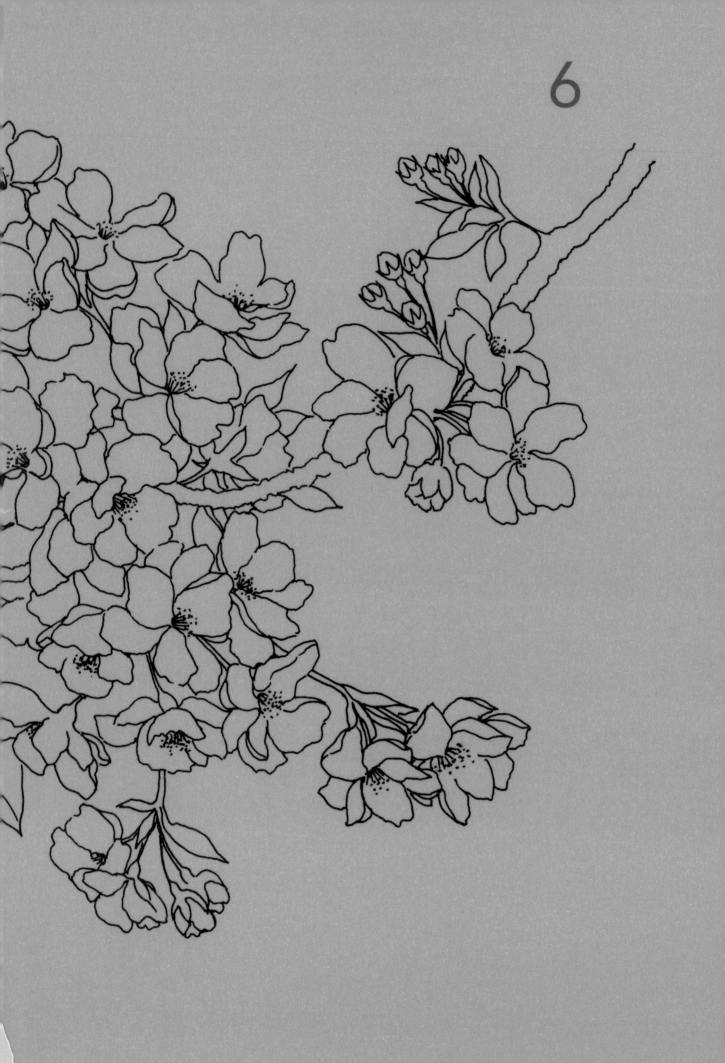

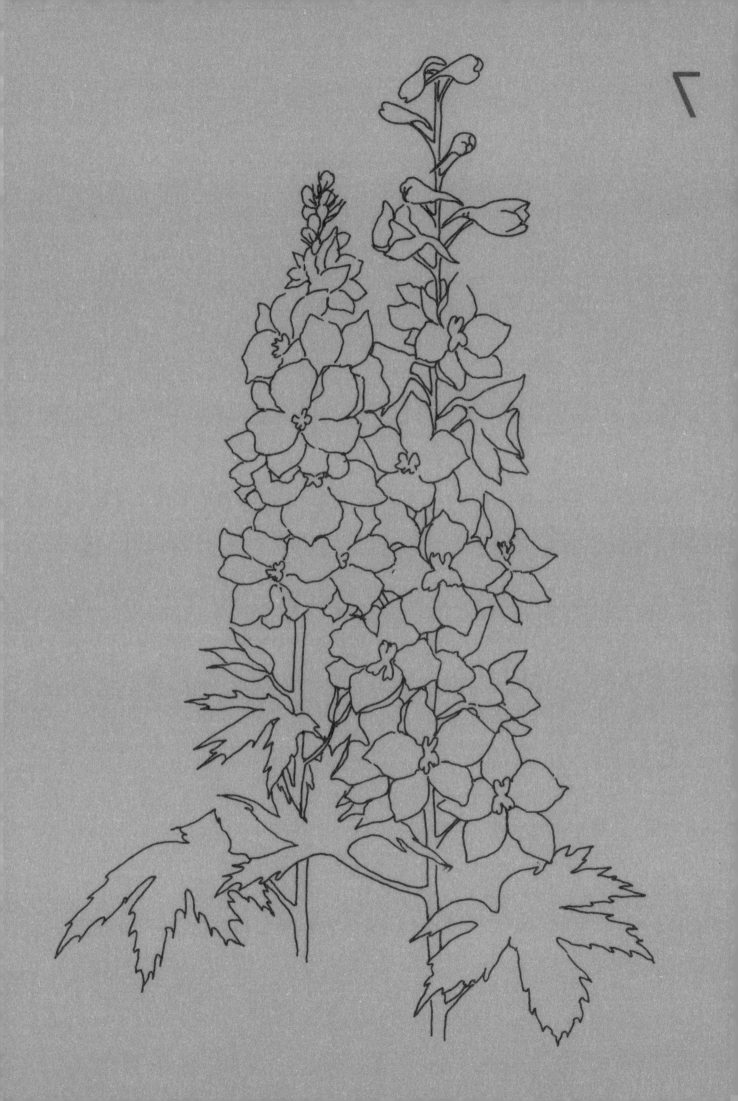

8

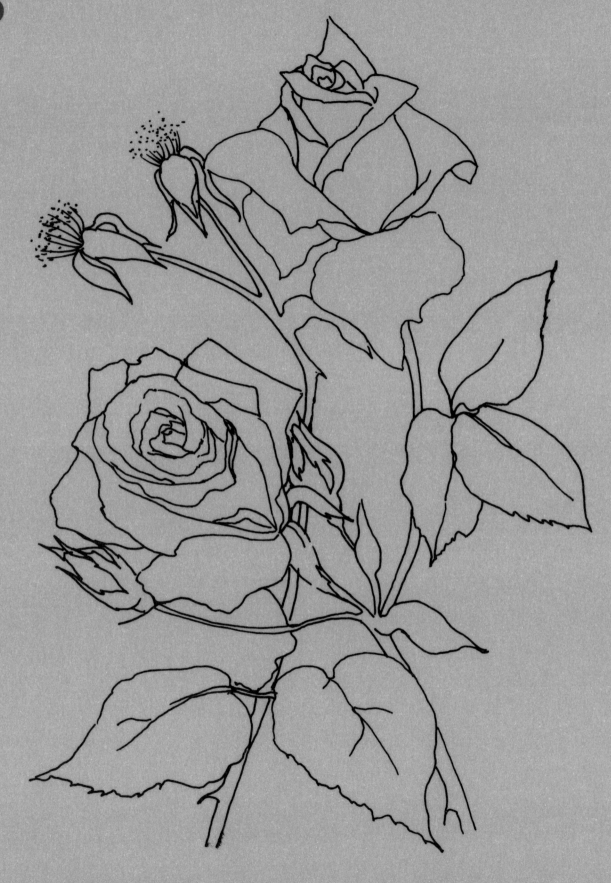

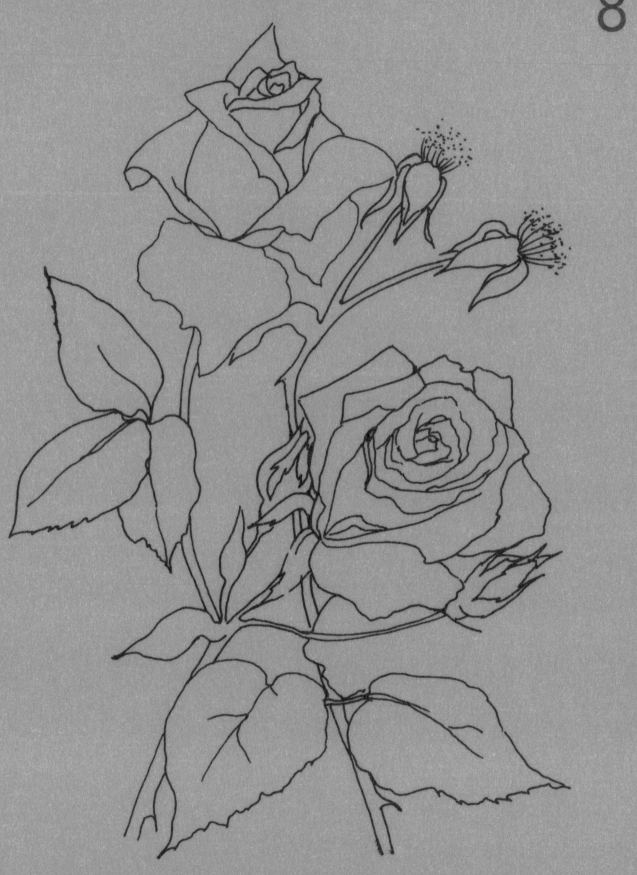

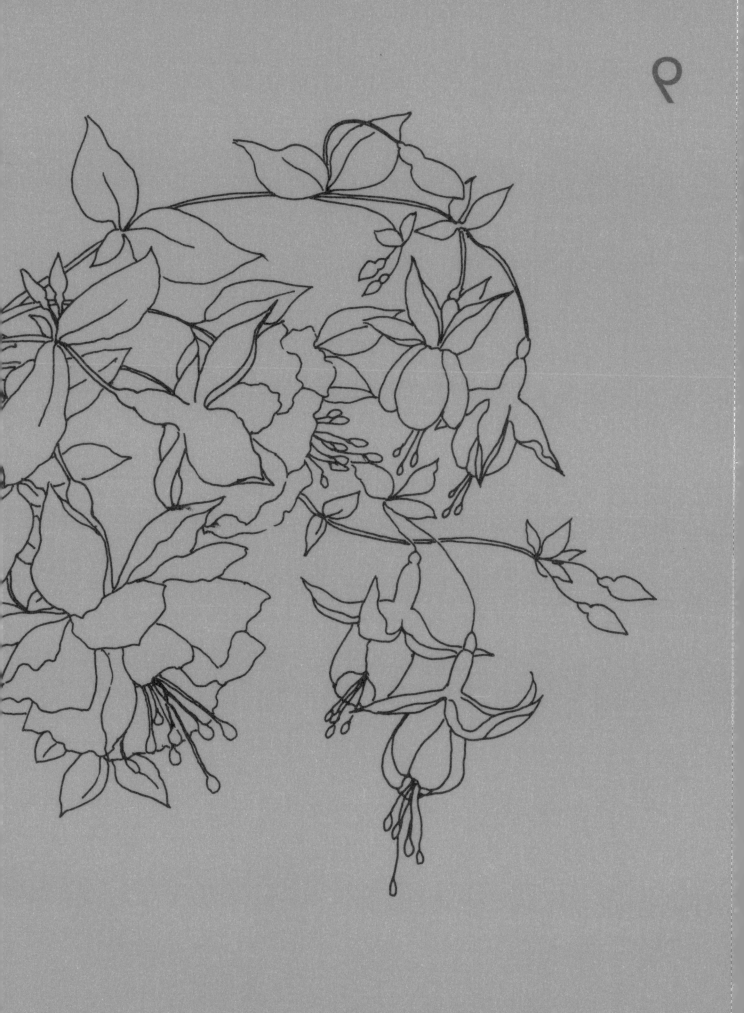

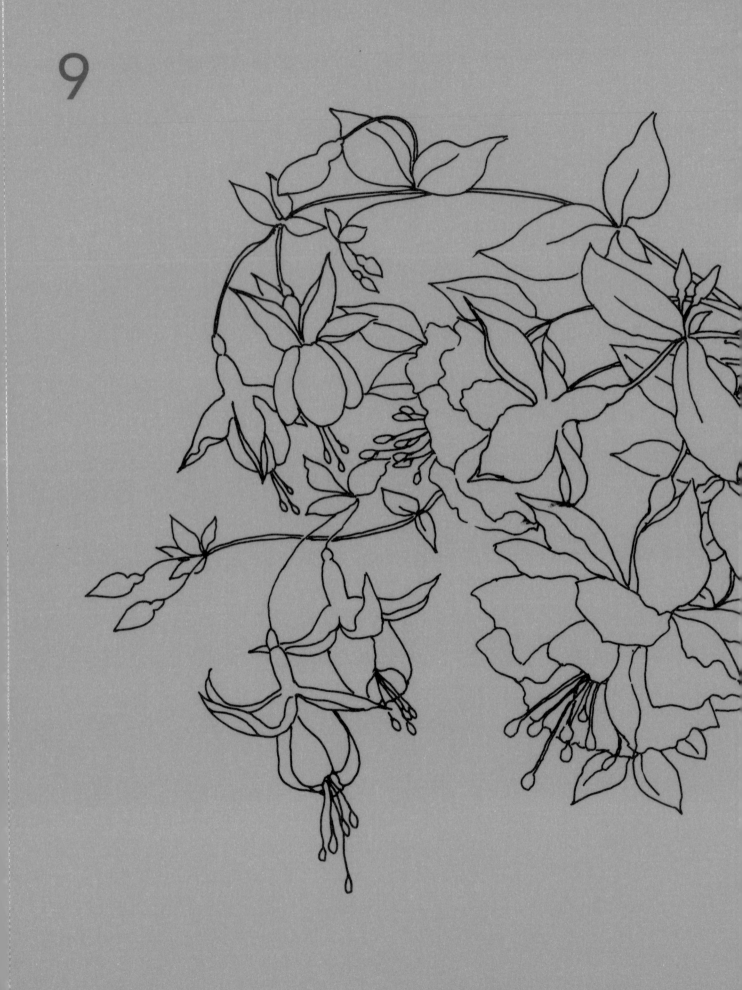

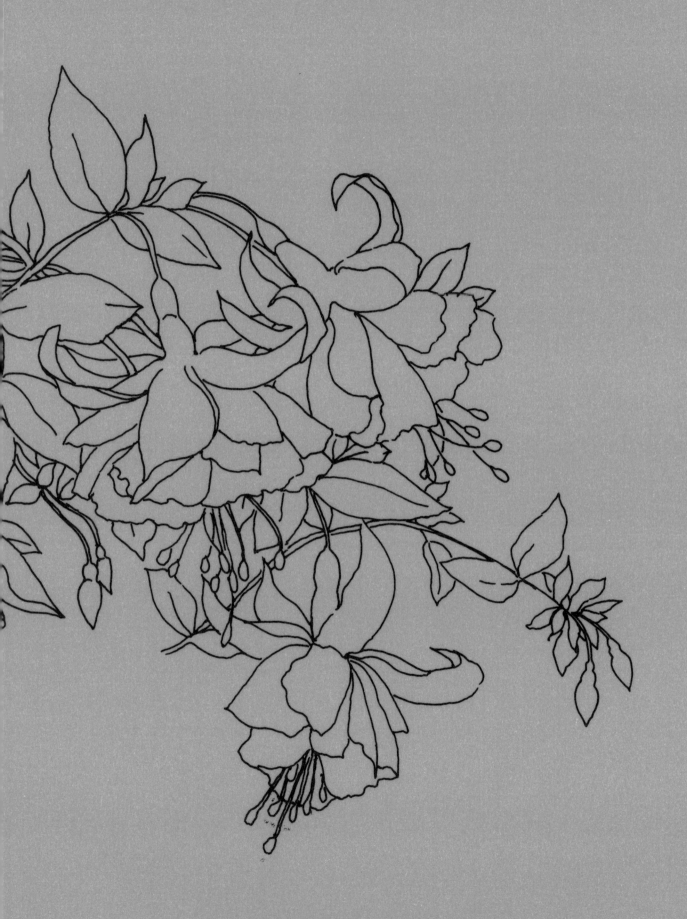

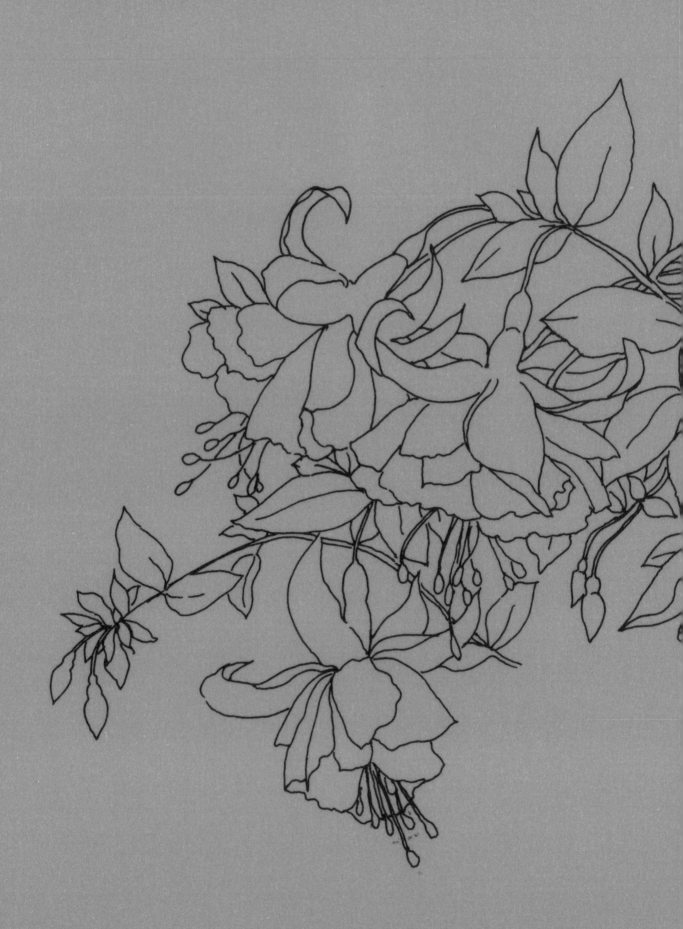

READY TO PAINT

Watercolour **Flowers**

Wendy Tait

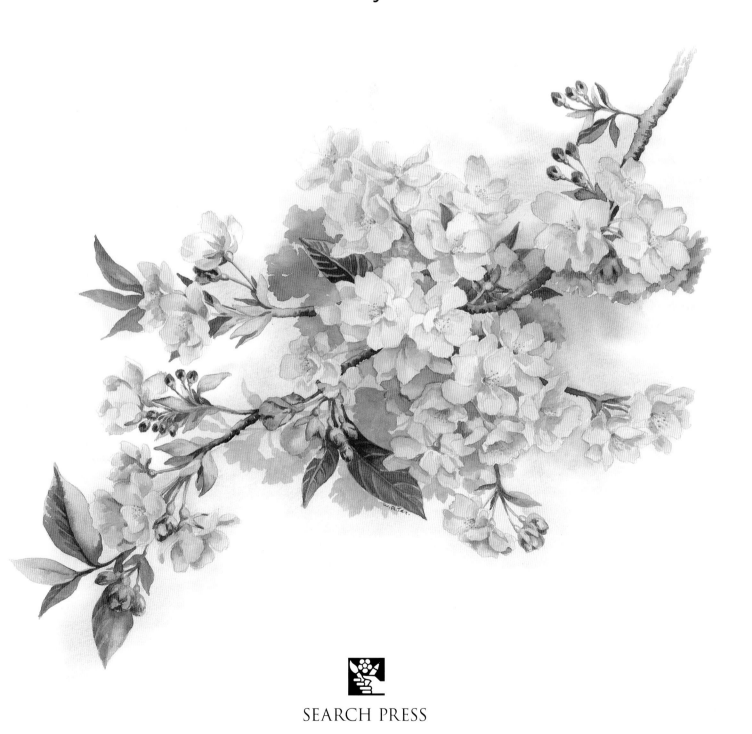

SEARCH PRESS

First published in Great Britain 2008

Search Press Limited
Wellwood, North Farm Road,
Tunbridge Wells, Kent TN2 3DR

Reprinted 2008 (three times), 2009 (three times), 2010 (twice),
2011(twice), 2012, 2013 (twice), 2014, 2015 (twice), 2016, 2017 (twice),
2018, 2019 (twice), 2020, 2022, 2024

Text copyright © Wendy Tait 2008

Photographs by Steve Crispe at Search Press Studios

Photographs and design copyright © Search Press Ltd 2008

Author photograph reproduced with the permission of
Derby Evening Telegraph

ISBN: 978-1-84448-284-9

The Publishers and author can accept no responsibility for any
consequences arising from the information, advice or instructions given in
this publication.

Readers are permitted to reproduce any of the tracings or paintings in
this book for their personal use, or for the purposes of selling for charity,
free of charge and without the prior permission of the Publishers. Any
use of the tracings or paintings for commercial purposes is not permitted
without the prior permission of the Publishers.

Suppliers
If you have any difficulty obtaining any of the materials and equipment
mentioned in this book, please go to the Search Press website:

www.searchpress.com

Publisher's note
All the step-by-step photographs in this book feature the author,
Wendy Tait, demonstrating her watercolour painting techniques.
No models have been used.

There are references to sable and other animal hair brushes in this book. It
is the Publishers' custom to recommend synthetic materials as substitutes
for animal products wherever possible. There is now a large range of
brushes available made from artificial fibres, and they are satisfactory
substitutes for those made from natural fibres.

**Please note that when removing the perforated sheets of tracing paper
from the book, score them first, then carefully pull out each sheet.**

Acknowledgements
With thanks to all my friends and students; past, present
and future, for all the encouragement they give me,
especially when the going gets tough!
Thanks also to the team at Search Press for their unfailingly
cheerful help and guidance.

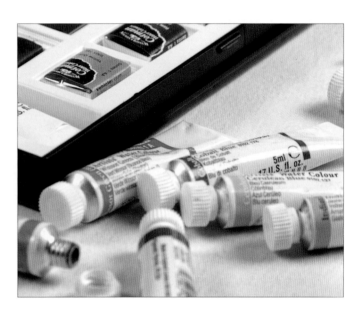

TRACING **6**

Page 1:
Prunus Blossom
43 x 28cm (17 x 11in)

TRACING **7**

Opposite:
Delphiniums
23 x 30cm (9 x 12in)
Note how the darks behind the pale flowers add contrast.

Contents

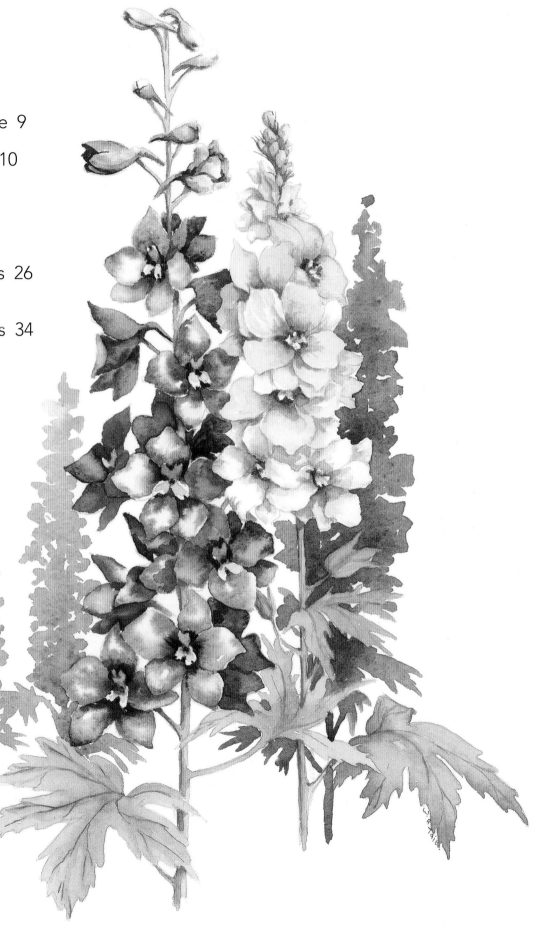

Introduction 4

Materials 6

Transferring the image 9

Poppies and Daisies 10
 Step by step

Roses 18
 Step by step

Pansies and Primroses 26
 Step by step

Jonquils and Daffodils 34
 Step by step

Clematis 42
 Step by step

Index 48

Introduction

You have always wanted to paint, you have some materials and time put aside, and suddenly, faced with that scary sheet of blank paper, you need help. This book will help you take those first daunting steps.

All of the paintings in the book, including the pictures on the previous pages and opposite, are provided as tracings in the centre pages for you to pull out and use. Each is simplified to show you that even a detailed painting can be tackled by concentrating on the main design. Try to ignore the 'clutter' that can make a picture look complicated and difficult to achieve. Once you have gained your confidence using these outlines, try producing your own paintings either from photographs or, best of all, real flowers.

After many years of painting, I now rarely use a pencil, drawing instead with my paintbrush. This takes a little practice, but gives added depth to your painting and creates a wonderful sense of freedom once you have gained enough confidence to let your imagination take over.

This book is a stepping stone to help you begin the exciting and fascinating journey into painting flowers. It may not always be easy, but if you persevere, it will give you both enormous pleasure and a great sense of satisfaction.

I hope you will like the subjects I have chosen, and that you will go on to develop your own style of painting flowers. So get ready to paint, and enjoy the adventure.

Wendy Tait.

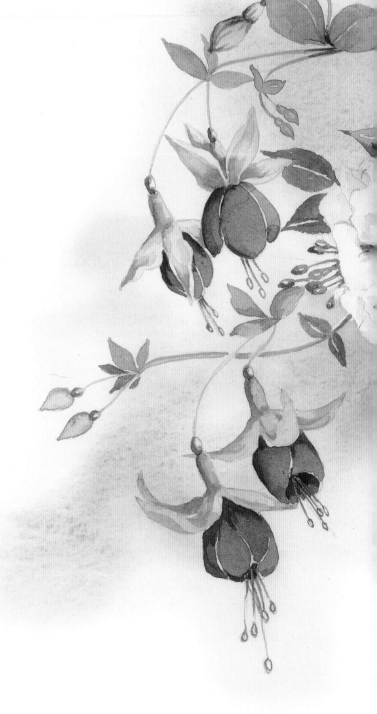

Fuchsias

42 x 30cm (16½ x 12in)

The background of this painting was dropped in first, then the flowers were painted on in the same way as the Clematis project on pages 42–47.

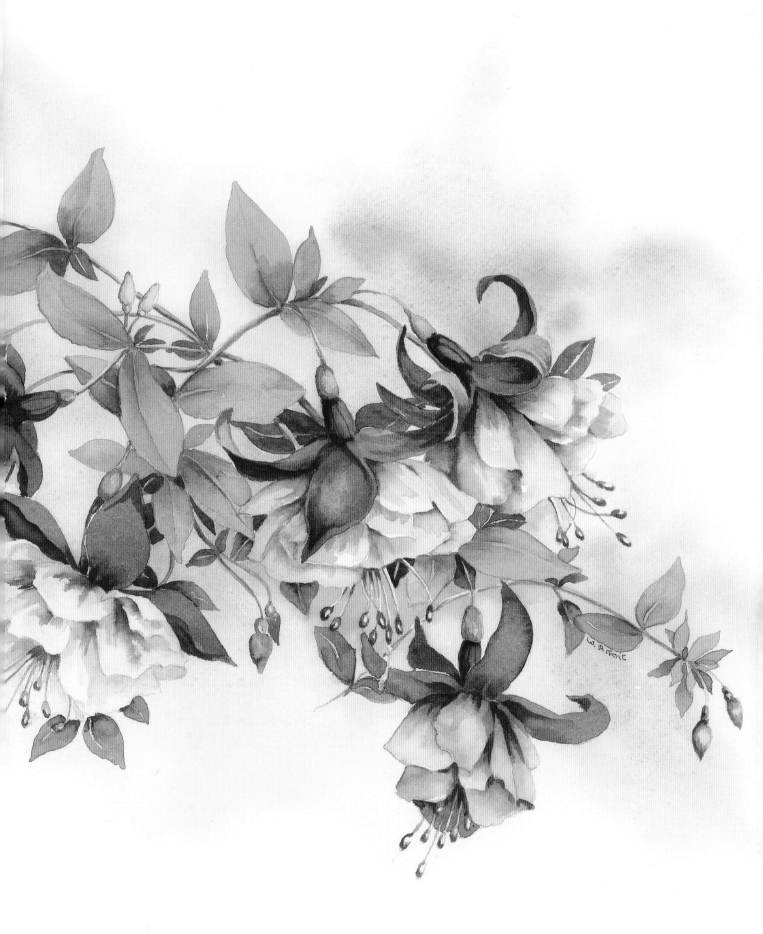

Materials

Paints

Watercolour paints are available in pans or tubes, and either type is suitable for painting flowers. I began painting with pans and gradually changed to tubes as I used up my original paints.

Artists' quality watercolour paints are more expensive than students' quality, but are much better. The artists' colours have less filler in them, making the paint truer and denser. While they are a little more expensive, in the long run they are a better investment, and will give you better results.

The colours I use for my flower-painting palette are cadmium orange, quinacridone magenta, permanent rose, cobalt violet, cobalt blue, brown madder, cadmium lemon, quinacridone gold, sap green and indigo. This is a slightly different range than the one I would use for landscapes. The last four on the list are used in varying quantities for the green mix used throughout the book, and enable a great variety of greens to be mixed.

Watercolour paints in tubes.

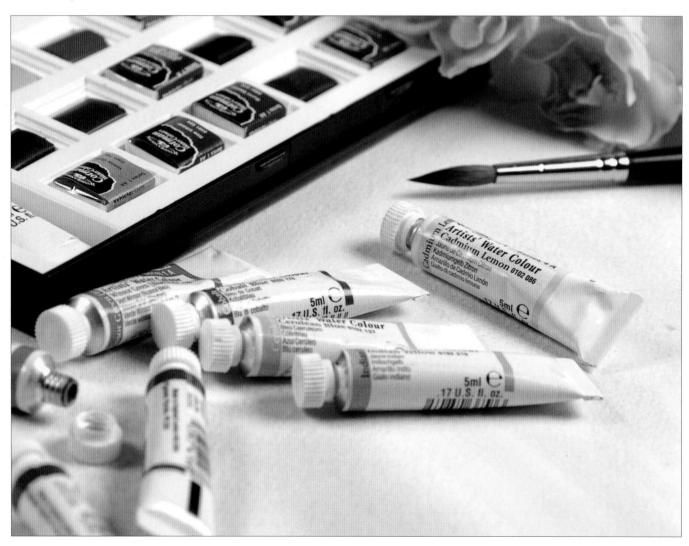

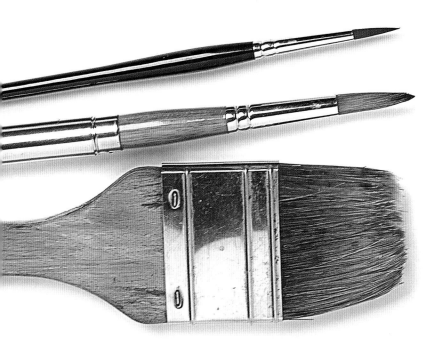

Brushes

There are many excellent brushes on the market, from synthetic nylon to pure sable.

I mainly use two brushes: a size 4 round (top) and a size 10 round (middle), both in a sable/synthetic mix. I prefer these to pure sable as they are firmer and much cheaper.

The big flat brush (bottom) is used to wet the paper when I am painting wet-in-wet before I drop in background colour.

The brushes I use for watercolour painting.

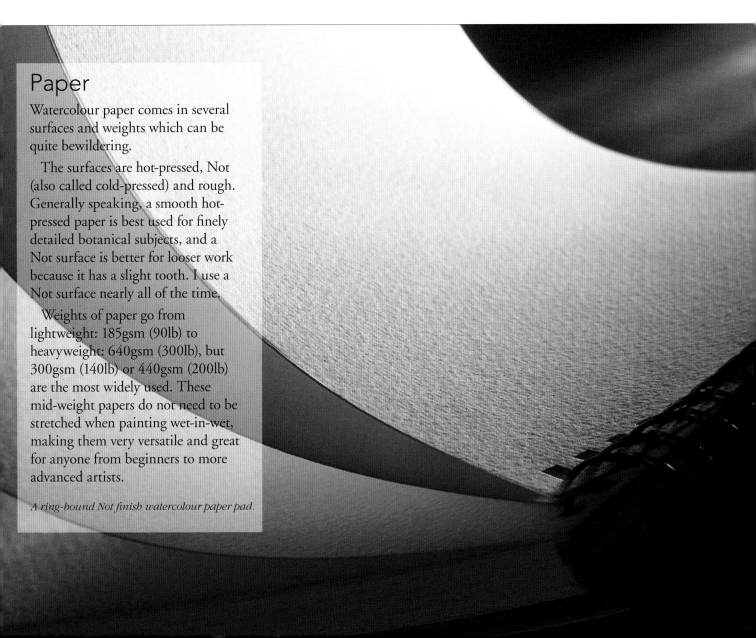

Paper

Watercolour paper comes in several surfaces and weights which can be quite bewildering.

The surfaces are hot-pressed, Not (also called cold-pressed) and rough. Generally speaking, a smooth hot-pressed paper is best used for finely detailed botanical subjects, and a Not surface is better for looser work because it has a slight tooth. I use a Not surface nearly all of the time.

Weights of paper go from lightweight: 185gsm (90lb) to heavyweight: 640gsm (300lb), but 300gsm (140lb) or 440gsm (200lb) are the most widely used. These mid-weight papers do not need to be stretched when painting wet-in-wet, making them very versatile and great for anyone from beginners to more advanced artists.

A ring-bound Not finish watercolour paper pad.

Other materials

A large **palette** with several mixing wells is essential. Paints can be squeezed into the smaller wells and left at the end of the session to save wasting them. They will last for several weeks without drying out.

I use a **cotton cleaning cloth** to dry my brush in between different colour washes, and also to dry off the brush when I want to use stronger colour: a dryer brush means more control.

Kitchen paper is occasionally useful to blot off excess paint if the colour is too dark.

I have a collapsible **water pot** that is light and easy to transport.

Masking tape is used to secure the paper to a board, unless you are using a pad or block of paper. Only tape the top edge as the paper will buckle when wet if it is held down all the way round.

Soft pencils are used for tracing the image on to your paper.

A **burnishing tool** is used for transferring the image from the tracing to the watercolour paper. A **spoon** makes for a convenient alternative.

A **wooden board** is also very useful, as you can then easily move and tip the painting without touching the paper.

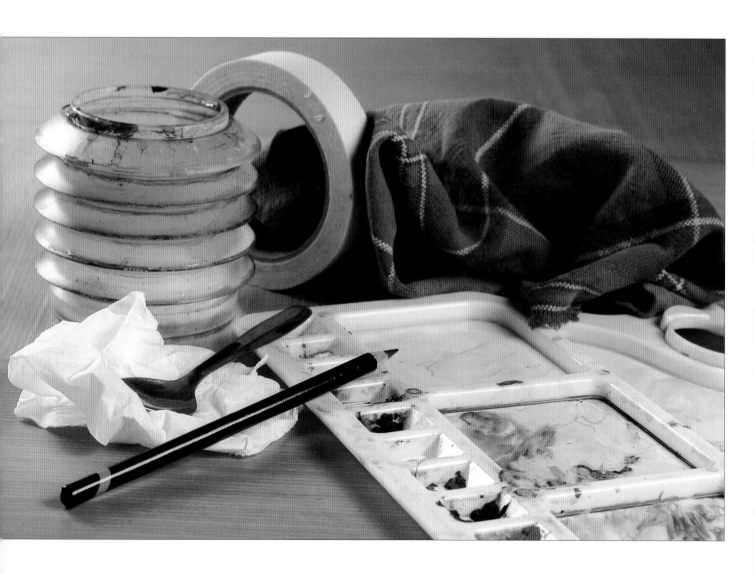

Transferring the image

Pull out the tracing you want to use from the front of the book, and follow
the instructions below to transfer the image to your watercolour paper.

I have used a spoon handle to transfer the image, but a burnishing tool or
the lid of a ballpoint pen would also work.

1 Place your tracing face-down on some scrap paper. Go over the lines on the back using a 4B or 2B pencil. This is a section from the Poppies and Daisies project (see pages 10–17). You will be able to reuse this tracing several times without going over the pencil lines again.

2 Tape a sheet of A3 watercolour paper down on a board, and place the tracing face-up on top. Tape down the top of the tracing only. Use the handle of a spoon to go over the lines.

3 You can lift up the tracing from the bottom as you work, to see how the transfer of the image is going.

Poppies and Daisies

Poppies are a very popular subject, but they are often painted with too strong a tone of red, leaving the flower opaque and uninteresting. This project uses a thin wash of cadmium orange to start, giving a luminous glow to the poppy petals, which is much more suited to watercolour.

You will need

300gsm (140lb) Not finish watercolour paper

Masking tape

Cleaning rag

Board

Colours: cadmium orange, permanent rose, cobalt blue, cadmium lemon, indigo, quinacridone gold, quinacridone magenta

Brushes: size 10 round sable mix, size 4 round sable mix

TRACING

1

1 Transfer the image to the paper, then tape the top of the paper to your board. In a large-welled palette, place a small amount of cadmium orange, permanent rose and quinacridone magenta so that they remain separate but can be drawn together.

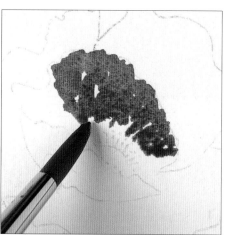

2 Dip the size 10 brush in water and then into the cadmium orange. Begin to paint the topmost poppy, drawing the paint down from the edge of the inner petal. Dip the brush in the quinacridone magenta and pull the colour down, allowing the wet paint to mix.

10

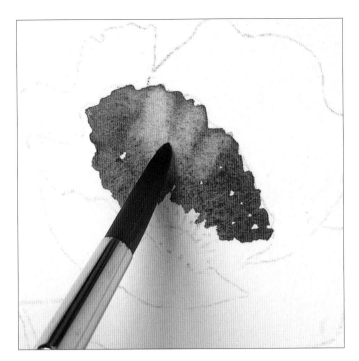

Tip

As you continue, add more neat paint to the mix to keep the colour vibrant.

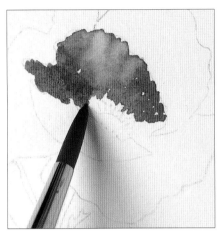

3 Clean the brush, dry it and then lift out highlights from the poppy petal by laying the dry brush firmly down on the paint. You may need to do this several times, washing and drying the brush each time, to lift out sufficient paint.

4 Pick up permanent rose and quinacridone magenta on the brush and use it to paint the shaded part of the petal.

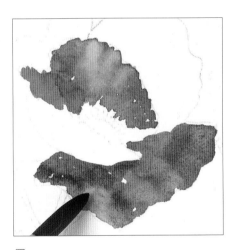

5 Move on to the lower right-hand petal and paint it in the same way, using the lighter mix and then adding the shaded mix nearer the centre of the flower. Lift out highlights with a clean, dry brush.

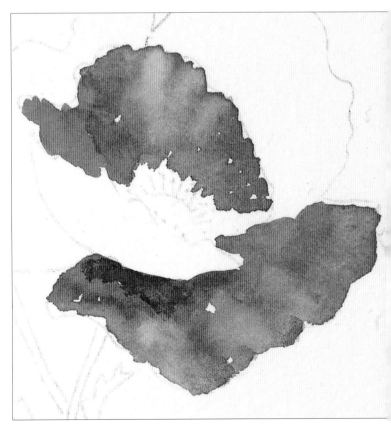

6 While the paint is wet, add a touch of indigo into the shadows.

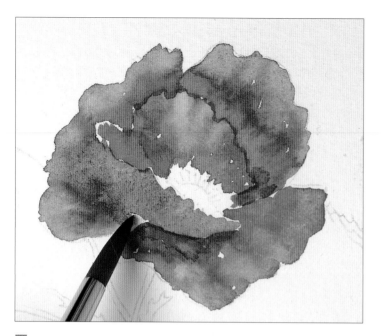

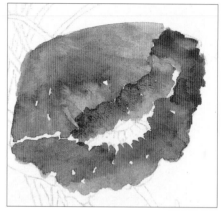

7 Paint the remaining petals of the top flower in the same way, allowing each to dry before continuing.

8 Paint the bottommost flower in the same way. Leave a tiny white line in between the petals.

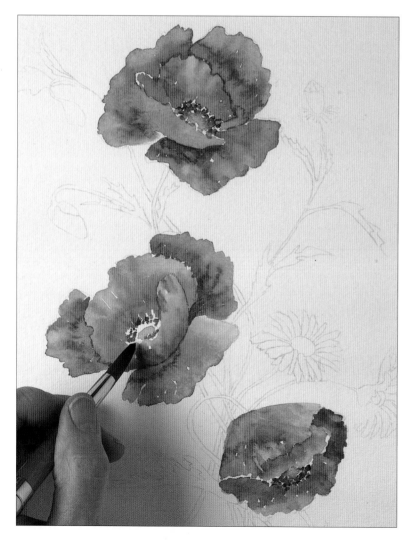

9 Paint the third flower, then make a mid-green mix of cadmium lemon, quinacridone gold and a touch of indigo. Use this mix to paint the green centres and one or two of the stamens of the flowers.

10 Use the green mix with the size 4 brush to paint the lighter parts of the stems, starting from the top.

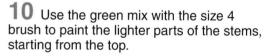

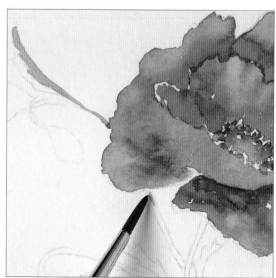

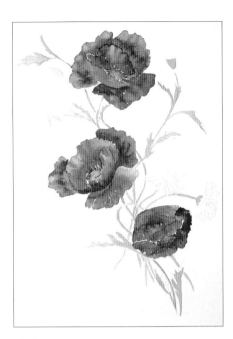

11 Paint all of the lighter parts of the stems in the same way.

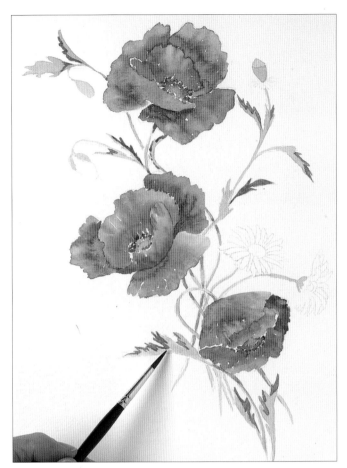

12 Add a little more indigo and quinacridone gold to the mix, and use this darker green to paint the green parts in shadow.

13 Use the side of the size 4 brush with the dark green mix to shade the right side of the bud. Clean and dry the brush, then draw the paint to the left to soften the shading.

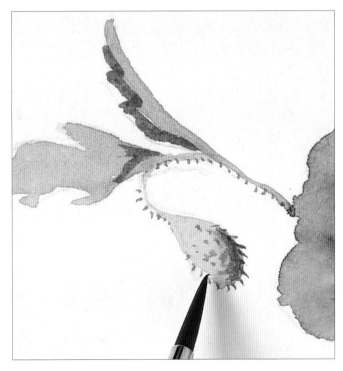

14 Allow to dry, then use a strong mix of the dark green to paint in the fine hairs on the buds and stem.

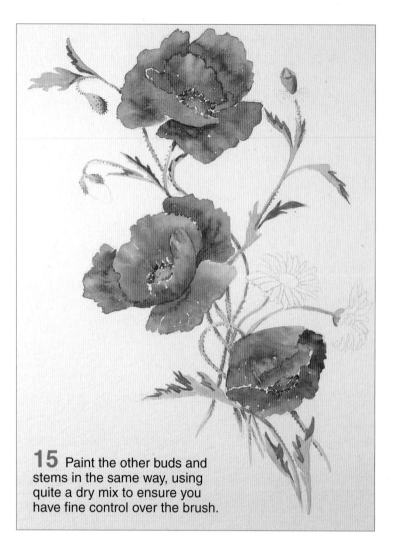

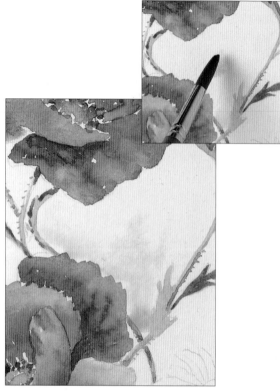

15 Paint the other buds and stems in the same way, using quite a dry mix to ensure you have fine control over the brush.

16 Allow the painting to dry, then make a thin wash of cobalt blue. Use the size 10 brush to wet the area in between the poppies, then drop in the blue wash in the centre of the area (see inset) before drawing it down to the poppies.

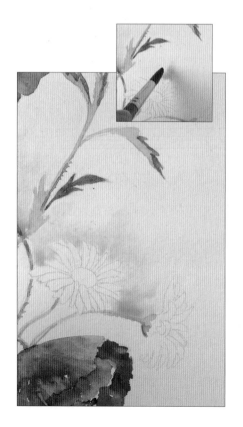

17 Wet the area behind the daisies on the right, making sure the water goes right to the edges of the paper. Drop in the blue mix a little way above the daisies (see inset) before drawing the paint down around them.

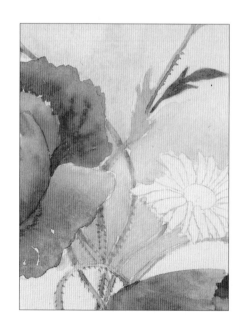

18 Draw the blue mix over and around the stems. If the green bleeds a little, allow it to dry completely, then use your green mixes to reinstate the colour on the stems.

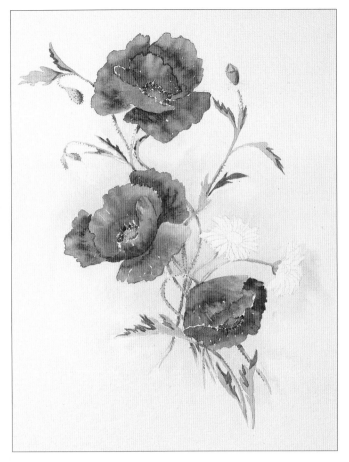

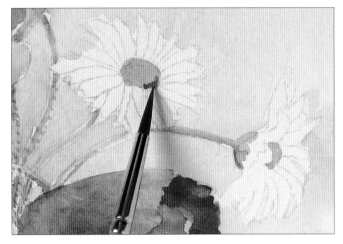

Tip
Try not to overwork any part as this can spoil the freshness of the finished painting.

19 Paint the rest of the background in the same way. Use plenty of water and do not drop the paint near the edge of the wet areas or it will dry in lines.

20 Make a light mix of cadmium lemon and quinacridone gold, and a darker mix of cadmium orange and quinacridone gold. Use the lighter mix to paint the centre of the daisies, then add the darker mix wet-in-wet around the edges to provide shading and definition.

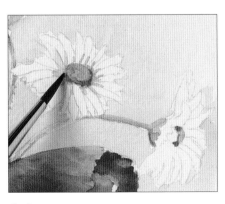

21 Wet the brush, dry it, and then use it to soften the centres of the daisies. Re-wet your green mix and use it to work down the lines of the petals to the centre of the daisy on the left.

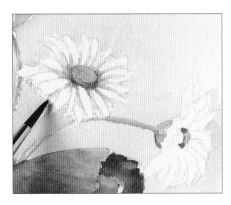

22 Add a touch of indigo to the green mix and strengthen the shadows in the very centre to provide modelling and shading.

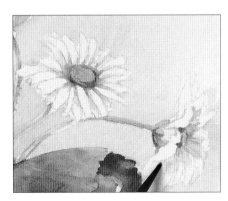

23 Repeat on the other daisy, taking note of where the shadows would lie.

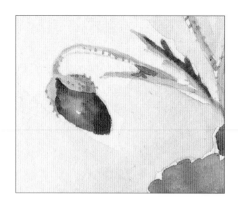 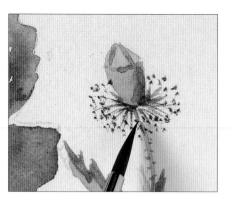 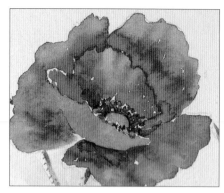

24 Paint the poppy bud at the top left of the painting, using the same mixes and techniques as when painting the poppy petals.

25 Use a very dry wash of indigo and very light strokes of the size 4 brush to paint the sepals of the seed pod at the top right.

26 Use the same indigo paint to detail the inside of the poppies.

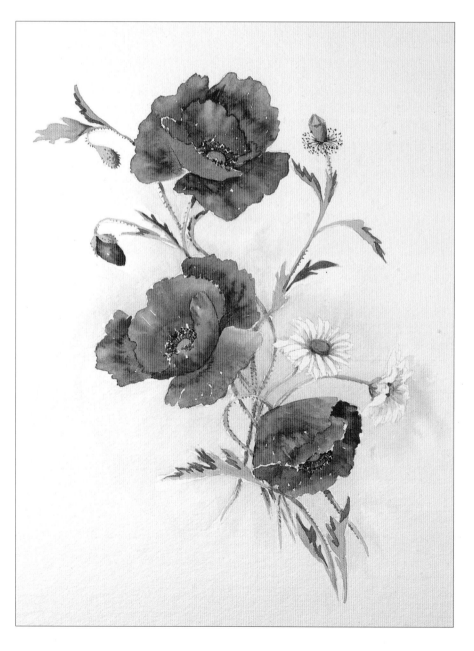

27 The painting is now complete and can be left as it stands (see left). Alternatively, extra detail can be added once the painting is completely dry, by adding thin glazes of paint to enhance and strengthen the colour, as seen opposite.

Opposite

The finished painting. You could paint some grasses behind the flowers if you want to add further detailing.

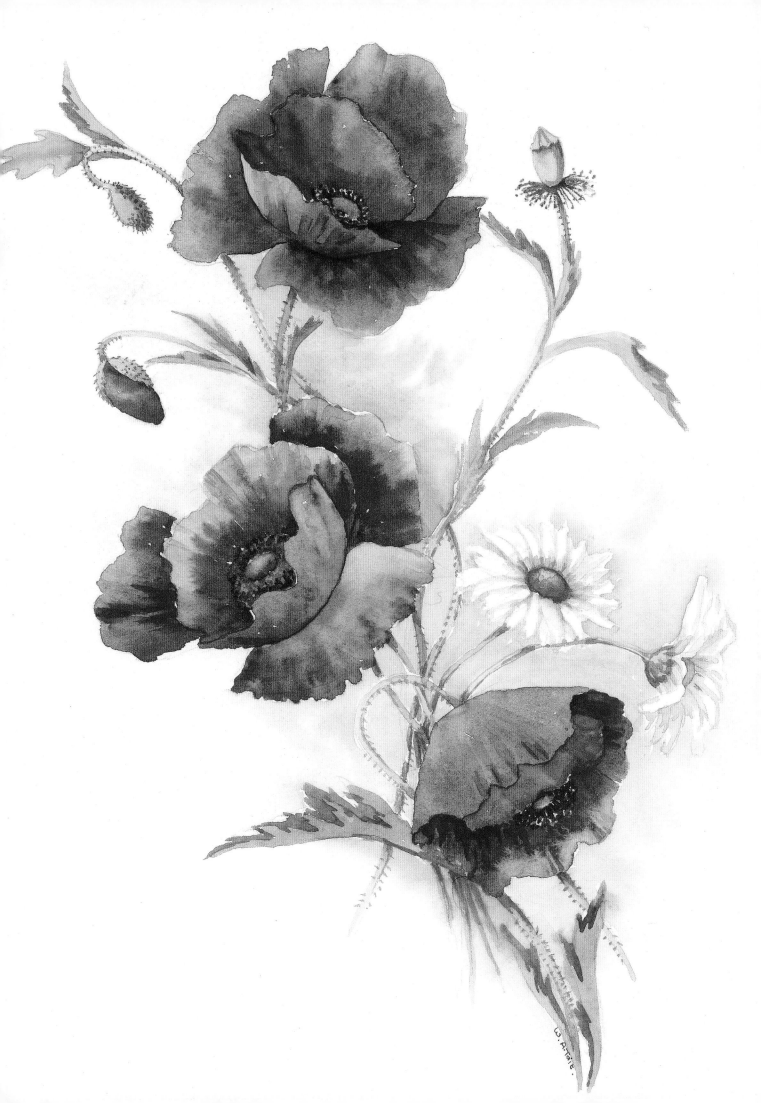

Roses

Many beginners assume that roses are 'too difficult' and avoid these lovely flowers. However, the technique for painting them is just the same as in anything else in watercolour, so it is well worth having a go at roses.

The blue shading used here is almost transparent on the edge of the petals, so you must use a very thin wash. The warmer golds in the centres will be painted using a thicker wash.

You will need

300gsm (140lb) Not finish watercolour paper

Masking tape

Cleaning rag

Board

Colours: cadmium lemon, quinacridone gold, permanent rose, brown madder, cadmium orange, indigo, cobalt blue, cobalt violet

Brushes: size 10 round sable mix, size 4 round sable mix

1 Transfer the image to paper and secure it to the board with masking tape. Use a size 10 brush to wet a petal of the central rose, then drop in a mix of cadmium lemon and quinacridone gold. Draw the paint towards the centre, leaving plenty of paper showing through for highlights.

2 Add a little extra quinacridone gold to the mix as you reach the bottom of the petal for shading. Adding extra quinacridone gold warms the colour.

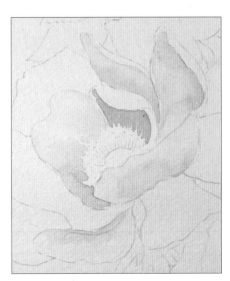

3 Paint the other inner petals of the rose in the same way, working wet-in-wet. Note that the closer the petal is to the centre of the flower, the warmer the colour.

18

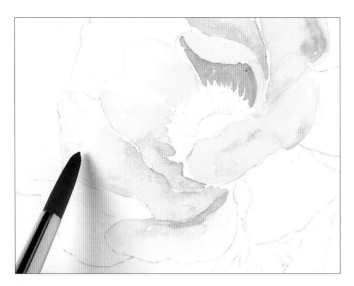

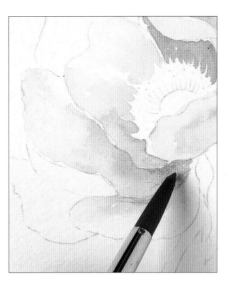

4 Move on to the outer petals, using a mix with more cadmium lemon. Drop the paint in the centre of the petals and draw it towards the centre of the flower. Working wet-in-wet, add a thin wash of cobalt blue to the outside edges of the petals, allowing it to bleed into the yellow.

5 Once the flower is dry, clean the brush, dry it, and add a touch of quinacridone gold wet-on-dry in the deepest recesses of the flower near the centre. Soften the edge with water.

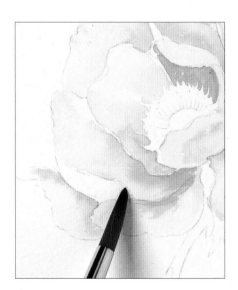

6 Paint the rest of the outer petals in the same way, with warmer mixes (i.e. more quinacridone gold in the mix) on the inside and for shading, and cooler mixes (more cadmium lemon) on the outside and for highlights. Use a touch of thin cobalt blue for the edges of the petals as before.

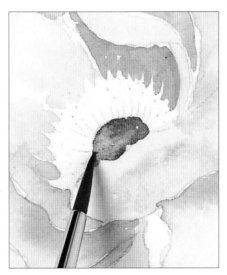

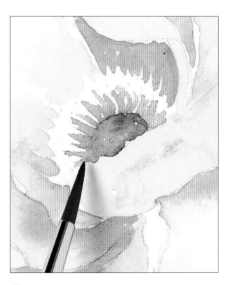

7 Make a thin mix of brown madder and paint in the rose's centre. Draw a clean damp brush across the middle of the area to lift out a little of the paint and create a highlight.

8 Draw the paint out while wet to form stamens. For finer control, draw your brush lightly over a cloth rag to draw off excess paint and water.

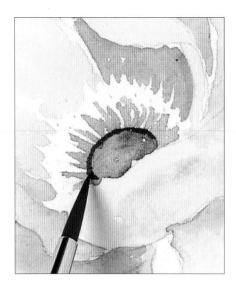

9 Make a stronger mix of brown madder with cobalt violet, and draw a fine line around the centre of the rose.

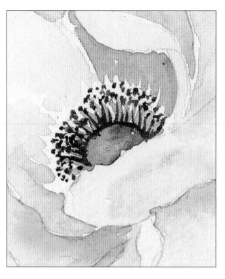

10 Draw the paint out to form darker stamens, then stipple the tips by dotting paint on to the very ends of the paint strokes.

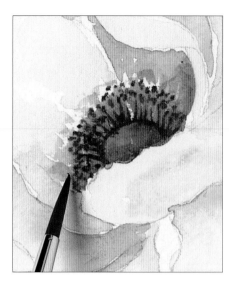

11 Allow to dry thoroughly, then glaze the centre with a thin wash of quinacridone gold and cadmium orange to complete the central rose.

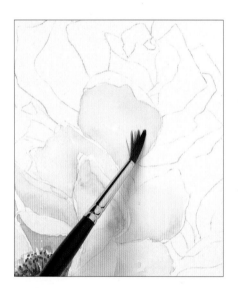

12 Make a stronger mix of cadmium lemon and quinacridone gold and draw a wide, wet outline round one of the petals of the flower above the completed rose.

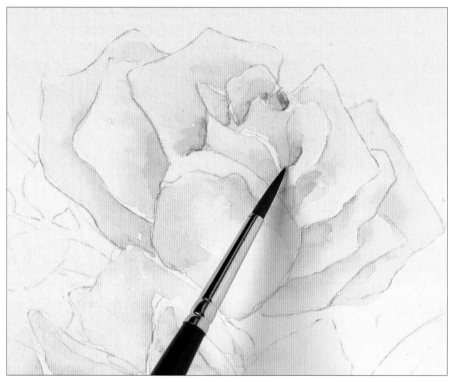

13 Paint the other petals of the uppermost flower, adding a touch more quinacridone gold on the central petals. At the very centre, add a touch of cadmium orange.

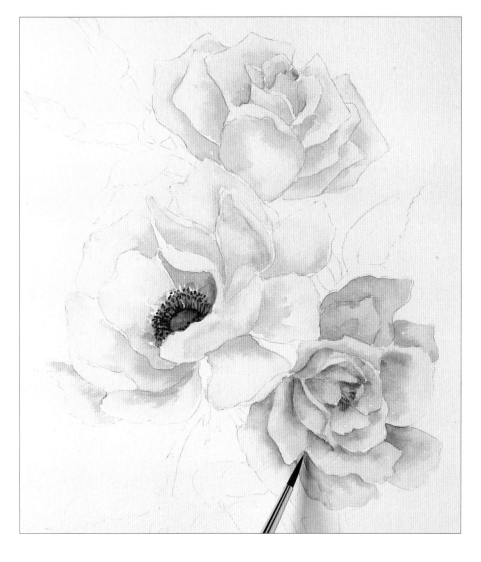

Tip
Watercolour paints will appear lighter when they are dry than when they are wet, so bear this in mind as you paint the shades.

14 Paint the flower at the bottom of the picture. This flower is warmer-toned, so use more gold in the basic mix, and add a touch of permanent rose for the shading.

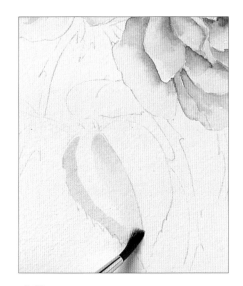

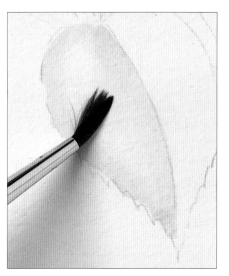

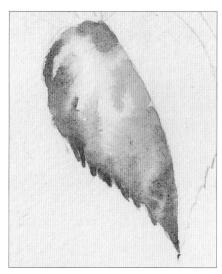

15 Make a thin mix of cobalt blue and use the size 4 brush to paint a thick outline round the left-hand segment of the large leaf at the bottom of the painting. Lay the brush almost flat to prevent a hard line from forming, and make sure that the paint is very dilute.

16 While the outline is still wet, drop clean water into the centre of the leaf and encourage the blue outline to blend into the water, leaving a light centre to the leaf.

17 Make a mix of cadmium lemon and quinacridone gold with a touch of indigo. Drop it in wet-in-wet as the blue paint starts to dry. Add a touch of indigo for shading at the edges.

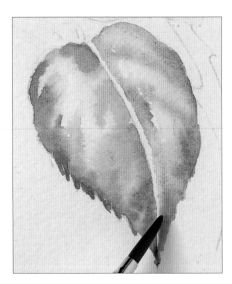

18 Paint the other half of the leaf in the same way, leaving a thin white border between the two.

19 Paint the remaining leaves with the same technique, paying attention to which parts of the leaves are in the shade.

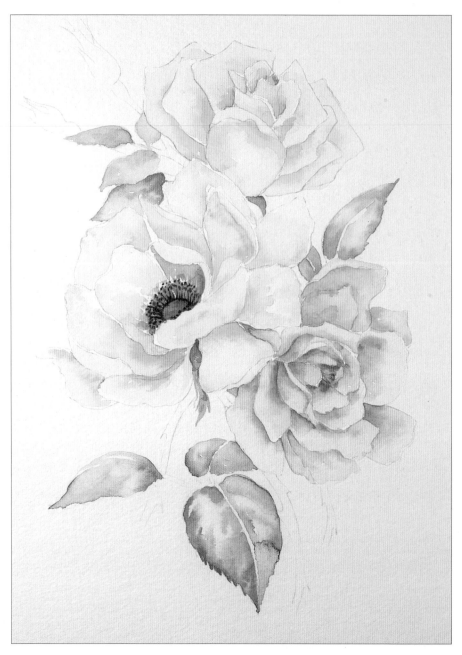

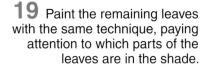

20 Add more cadmium lemon to the green mix and paint in the buds at the top of the painting, adding permanent rose wet-in-wet for the side in shadow. Finally, add fine detail to the bud with the dark green mix used on the leaves.

21 Pull the dark shade down the stem and then, without washing your brush, pick up some permanent rose and restate the whole stem. Soften the transition between the shading and main colour with a little water.

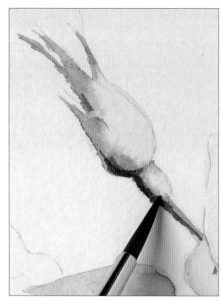

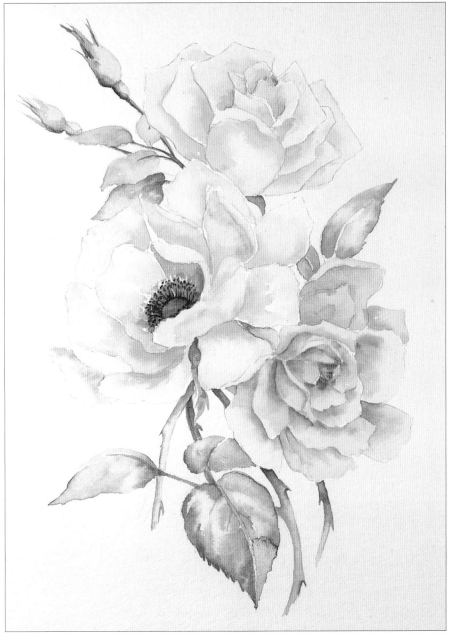

Tip
Where the stem is green, shade it with dark red. Where the stem is red, shade it with dark green.

22 Paint the other bud in the same way, then use the red and green mixes to paint the stems and thorns at the bottom. Deepen the red with brown madder for shading. This red mix can also be used for the veins of leaves.

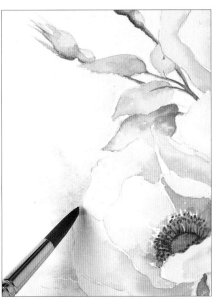

23 Wet the paper on the left-hand side right to the edge of the paper, then drop in a cobalt blue wash a finger's width from the painting and draw the wash towards the flowers.

24 If the paper is still wet, continue adding a faint blue backdrop around the flower. If it is dry or merely damp, allow it to dry completely, then re-wet it and continue until the background is completed. Where the background is completely enclosed by the picture, you can paint the blue wet-on-dry.

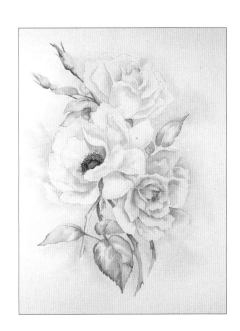

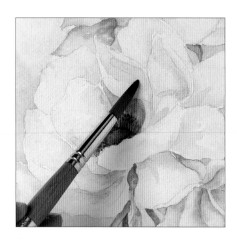

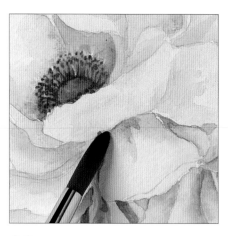

25 At this point, allow your painting to dry completely and decide if there is anything you would like to accentuate. In this case, I would like the central flower to be warmer. Add a glaze of cadmium lemon and quinacridone gold. Use a size 10 brush and take it swiftly over the area or areas that you wish to deepen.

26 Add a touch of the green mix to one of the lower petals. This increases the contrast between the cool and warm colours and adds to the impact.

27 Lift out part of the central flower's bottommost petal by running a clean, wet brush over it. Clean and dry the brush and repeat the process until a highlight is formed.

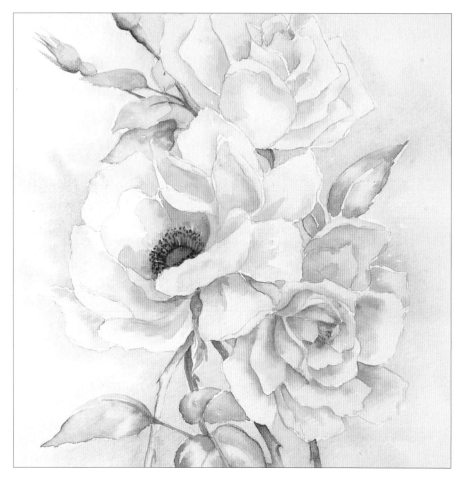

28 Allow the central flower to dry completely, then make any other changes you feel are necessary. Once you are happy with the painting, allow it to dry thoroughly and remove the masking tape to finish. You can remove the pencil lines with a clean eraser if you wish.

Tip

Be careful not to over-work the painting, as you will lose freshness and finish with a fussy appearance.

Opposite

The finished painting. There are two types of roses here: one lemon, the other a warmer golden yellow.

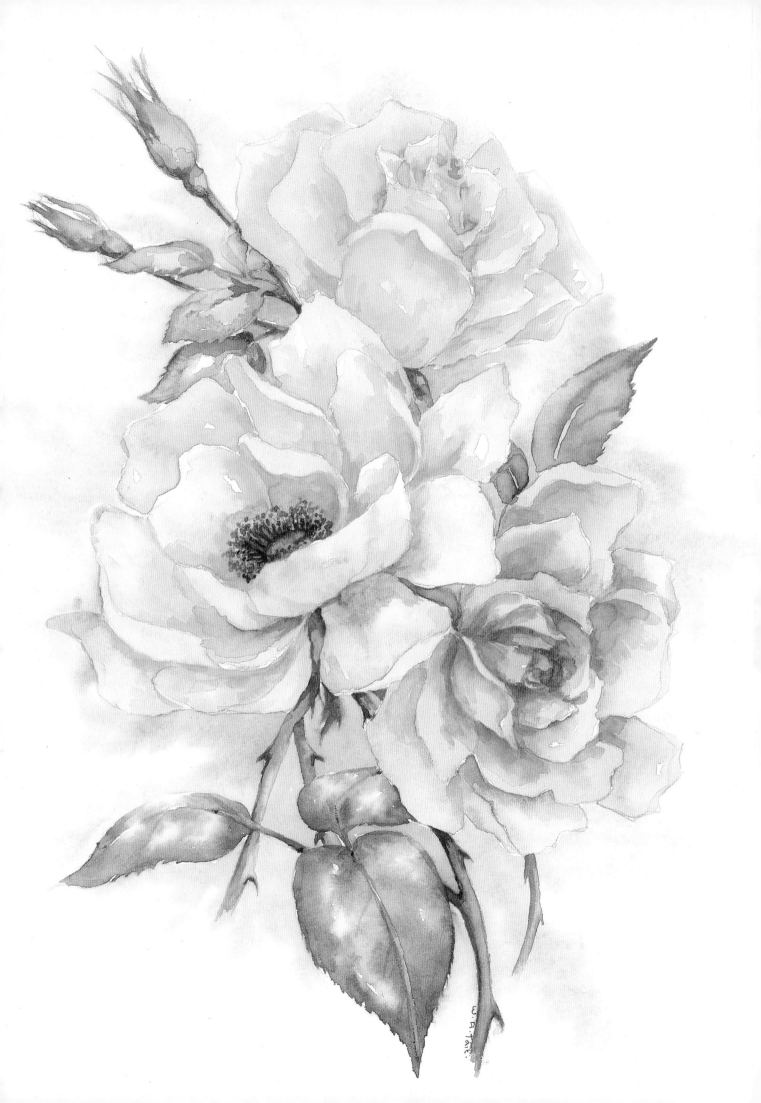

Pansies and Primroses

This painting may look complicated, but it is made easier by using small areas of darker tones behind the primroses, especially in the centre of the bunch. Note the softer tones used on the outermost flowers and the contrasting washes between them – blue behind yellow and vice versa.

You will need

300gsm (140lb) Not finish watercolour paper

Masking tape

Cleaning rag

Board

Colours: cadmium lemon, quinacridone gold, permanent rose, indigo, quinacridone magenta, cobalt blue, cobalt violet, brown madder, cadmium orange

Brushes: size 10 round sable mix, size 4 round sable mix

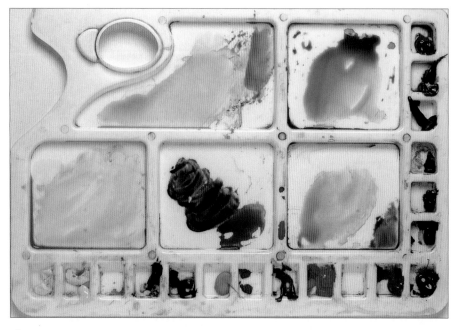

1 Transfer the image to your watercolour paper and secure it to your board with masking tape. Using the size 4 brush, prepare the following mixes: a mid-yellow made from cadmium lemon and quinacridone gold; a violet-blue made from cobalt blue with a touch of cobalt violet; violet-blue shadow made from quinacridone magenta, cobalt violet and cobalt blue; a mid-green made from cadmium lemon with a touch of indigo; and a rich brown made from brown madder and violet.

2 Use a very pale wash of cadmium lemon to paint a flat wash on the primroses using a size 10 brush.

TRACING
3

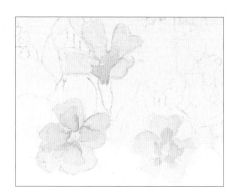

3 Combine some of the mid-yellow and mid-green mixes to paint the inner parts and shadows of the primroses. Soften the transition with water to avoid harshness.

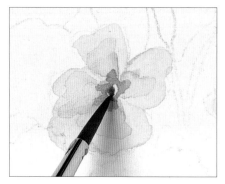

4 Once dry, use the size 4 brush with the mid-yellow mix to add the small markings to the central primrose. When dry, add a touch of mid-green wet-in-wet to the very centre.

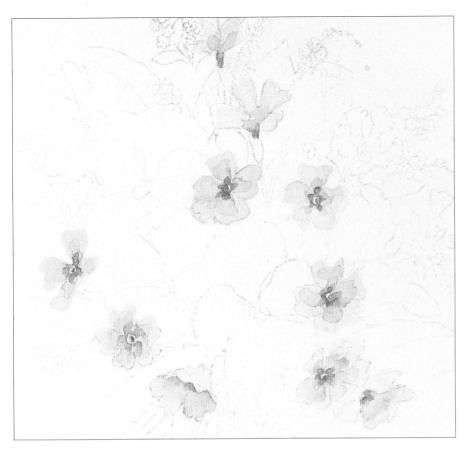

5 Use the same colours to detail the centres of the other primroses.

Tip

Leaving a thin white line between the petals of flowers helps to create a sense of delicacy.

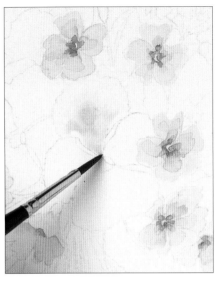

6 Use the size 4 brush to wet the top petal of the central pansy. Drop in a little mid-yellow in the middle of the petal and draw it down.

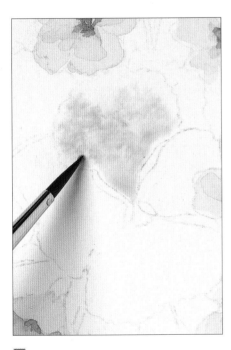

7 Working wet-in-wet, use the violet-blue mix to paint the top of the petal, allowing the paint to mingle with the yellow.

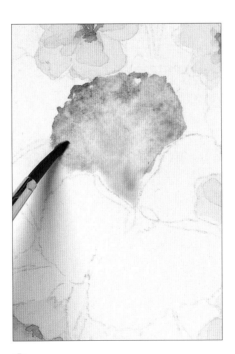

8 Finish the petal by adding a strong mix of the violet-blue shadow wet-in-wet to the edge of the petal.

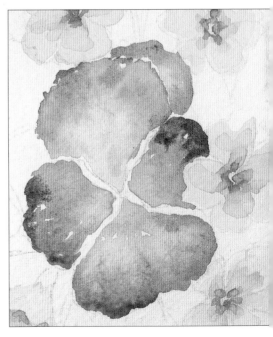

9 Paint the other petals of the pansy in the same way.

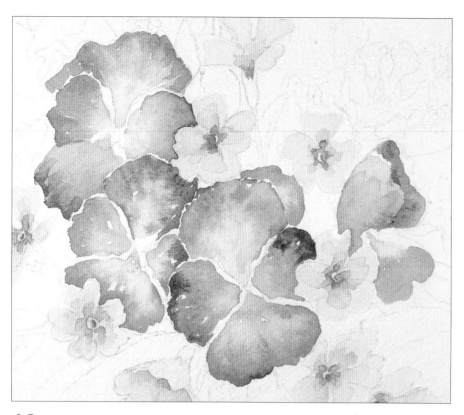

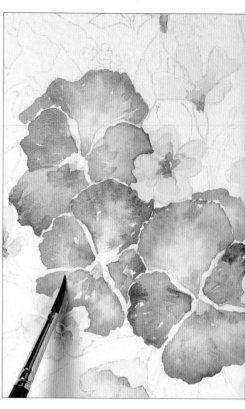

10 Still using the size 4 brush, paint the other two front-facing pansies and the one immediately to their right in the same way. Emphasise the edges of the petals with a slightly darker tone of the violet-blue shadow.

11 Paint and soften short streaks of cadmium orange towards the centre of the flower on the side and bottom petals of each pansy. Leave a small space at the very centre of each pansy, and allow them to dry thoroughly.

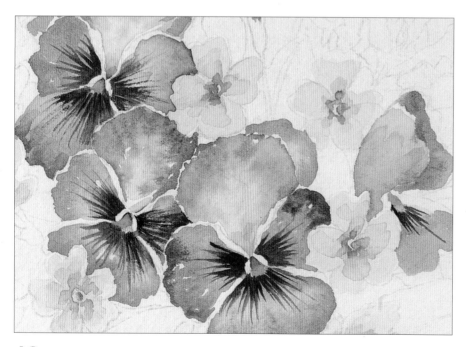

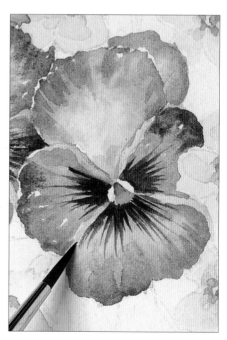

12 Add a touch of cobalt blue to the rich brown mix and use a strong, quite dry consistency to paint fine, feathered lines outwards from the centre of each pansy on the side and bottom petals. Use the same mix to outline the very centres of the pansies, then soften this with a little water.

13 Mix quinacridone magenta with permanent rose for a light pink and use this colour to add modelling to the pansy petals and to fill the turnbacks of the petals as shown.

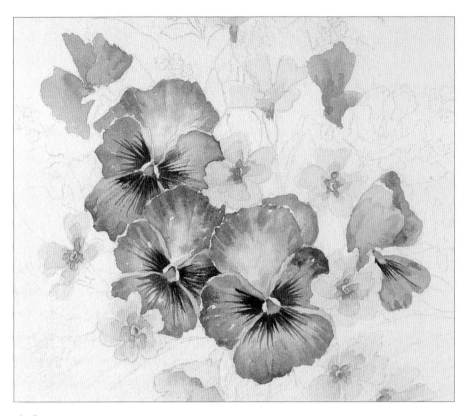

14 Paint the two pansies that face away from you with the colours used on the outer petals of the other pansies.

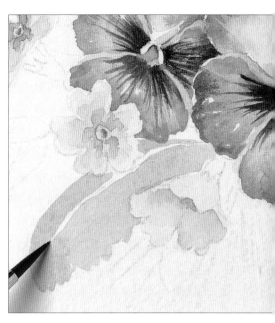

15 Make a soft green mix of cadmium lemon, indigo and quinacridone gold, and a mid-green mix of the same colours but with more indigo. Paint the primrose leaf on the bottom left with the soft green mix, leaving a line in the middle as shown.

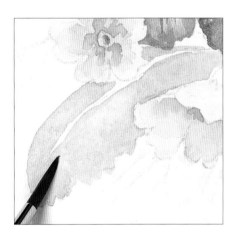

16 Quickly clean and dry the size 4 brush and lift out the lightest areas to add texture.

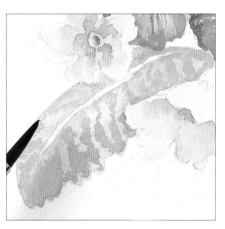

17 Working wet-in-wet, use the mid-green mix to add the pattern to the leaf and shading at the edge.

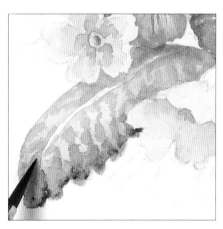

18 Make a mix of quinacridone gold and indigo for a dark green, and add fine detailing to model the edges of the leaf and where it is shaded by the flowers.

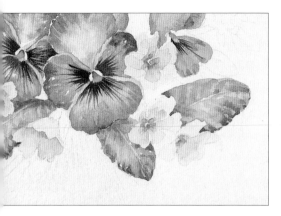

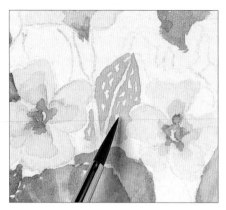

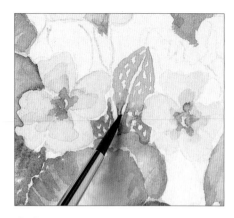

19 Paint the other two primrose leaves in the same way.

20 Use the mid-green to paint the upper part of the variegated leaf above the central pansy, leaving spaces of blank paper to show the white parts of the leaf.

21 Paint the part of the leaf that is in the shade with the dark green mix, remembering to leave spaces of plain paper as before.

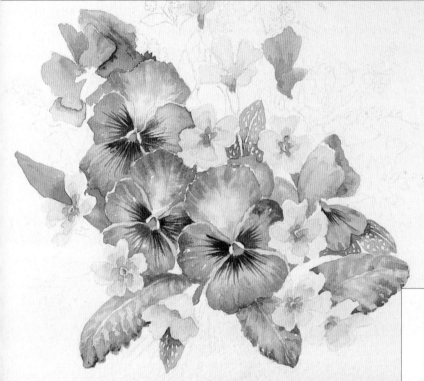

22 This two-tone approach can be used to paint the larger leaves of the remaining foliage, using dark tones where the leaf is in shadow. Add in any areas of the flowers that you may have missed earlier.

Tip

Adding the foliage will often help you identify what should go in a specific place and help highlight parts that you have missed.

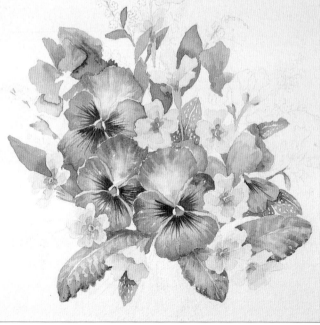

23 Use the mid-green and dark green mixes to paint in the stems and continue to fill in the foliage.

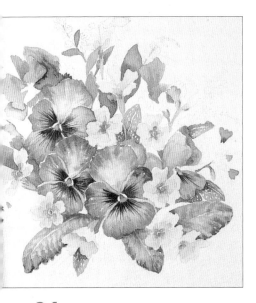

24 Using stronger and thinner washes of permanent rose, paint in the smaller pink flowers using the two-tone approach.

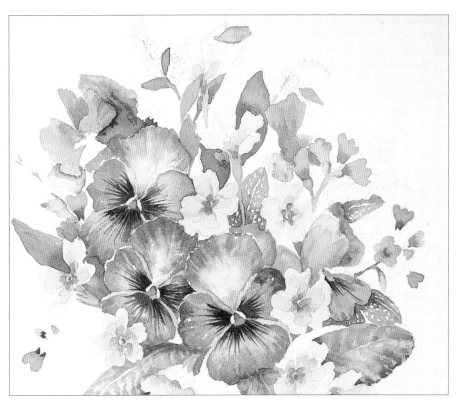

25 Paint the remaining smaller flowers with the violet-blue mix and the stronger permanent rose wash. A lovely deep pink can be achieved by not washing your brush between applications of permanent rose, and using a less dilute mix.

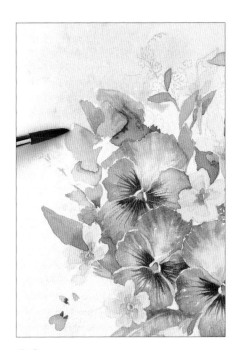

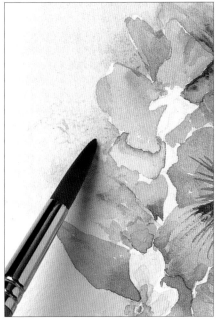

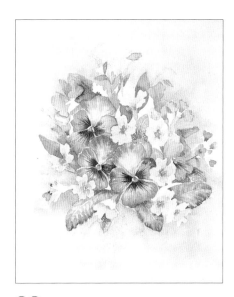

26 Use the size 10 brush to wet the top of the paper down to the flowers, then drop in a mix of cadmium lemon and quinacridone gold in above the flowers and foliage. Draw the bead of paint down to the edge of the flowers and over the tiny flowers to create a rich background.

27 Clean and dry the brush and add a thin wash of cobalt blue wet-in-wet around the very edge of the picture, letting it bleed into the yellow wash.

28 Continue wetting the paper and painting yellow and blue washes wet-in-wet around the picture. Work in sections, making sure you add paint only where the paper is wet.

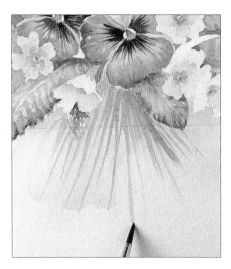 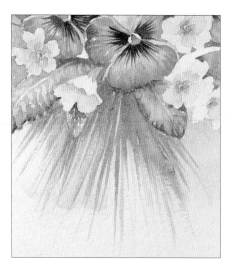 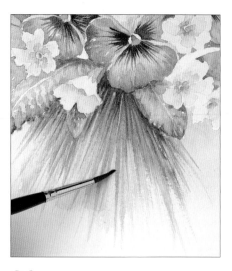

29 This is the fun bit! Allow the painting to dry thoroughly, then use a size 4 brush with mid-green to begin to paint the stems in sweeping strokes away from the bottommost pansy.

30 Use the violet-blue shadow mix to paint strokes in between the stems, allowing the new colour to bleed slightly into the green. You may find that turning the board while you work makes painting the strokes easier.

31 Use a much stronger mix of violet-blue shadow with a touch of brown madder to paint further strokes to complete the stems.

Tip
When building up colours in this way, a good rule of thumb is: the darker the tone, the smaller the area you should cover.

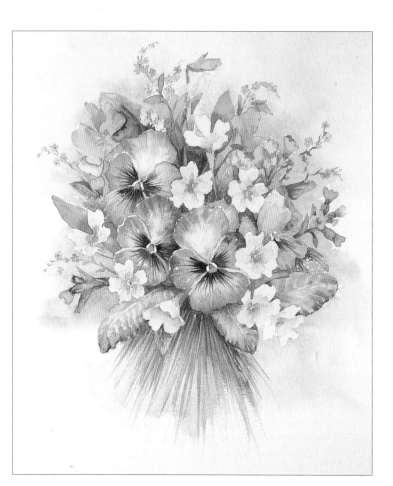

32 Use the same mix to paint the darks between the flowers and foliage, then paint in the stems of the tiny flowers with the mid-green mix. Use pale washes of the pink and purple mixes to complete the tiny flowers, then combine the mid-yellow and mid-green mixes to add a little modelling to the primroses to complete the picture.

Opposite

The finished painting. Notice that the flowers and leaves at the edges are kept very simple, keeping the details and focal point in the centre.

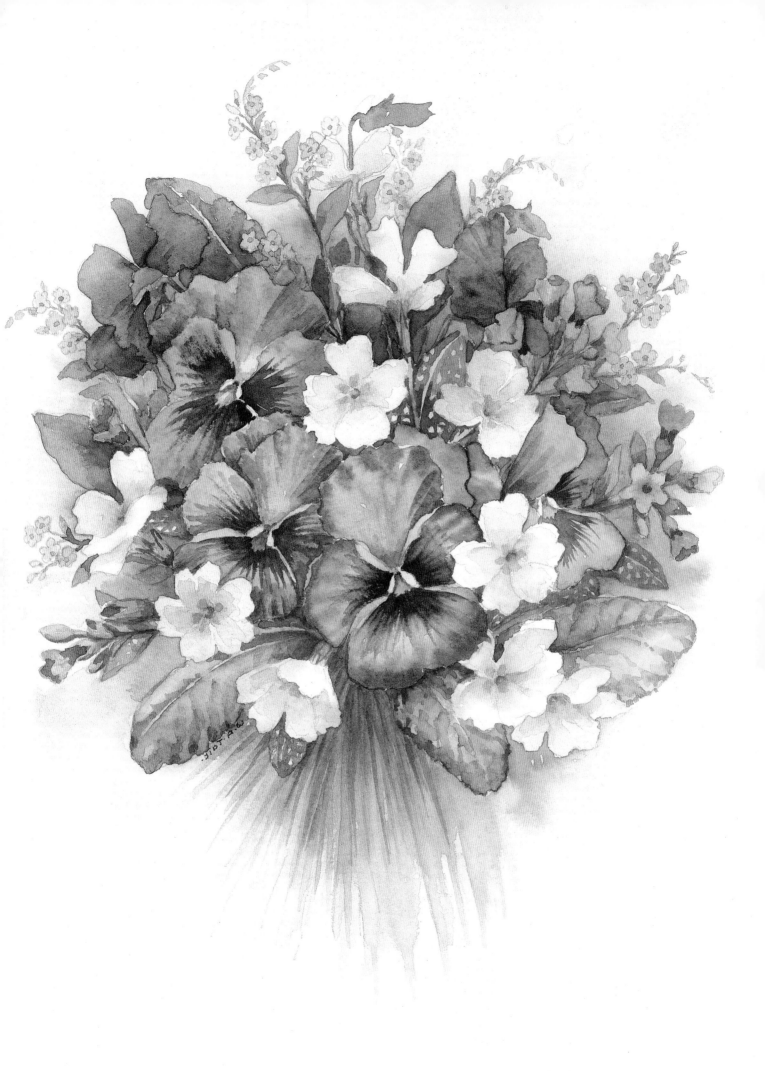

Jonquils and Daffodils

The problem of painting white flowers on white paper has been solved by placing yellow daffodils behind the white jonquils and by adding a pale blue background where necessary.

You will need

300gsm (140lb) Not finish watercolour paper

Masking tape

Cleaning rag

Board

Colours: cadmium lemon, quinacridone gold, cadmium orange, permanent rose, brown madder, indigo, cobalt blue, cobalt violet

Brushes: size 10 round sable mix, size 4 round sable mix

TRACING
4

1 Transfer the picture to paper and secure it on your board with masking tape. Find the central flower on the bottom row, and use a mix of cadmium lemon and quinacridone gold with the size 4 brush to paint the inside of the trumpet. Add cadmium orange wet-in-wet around the edge, allowing it to bleed into the yellow.

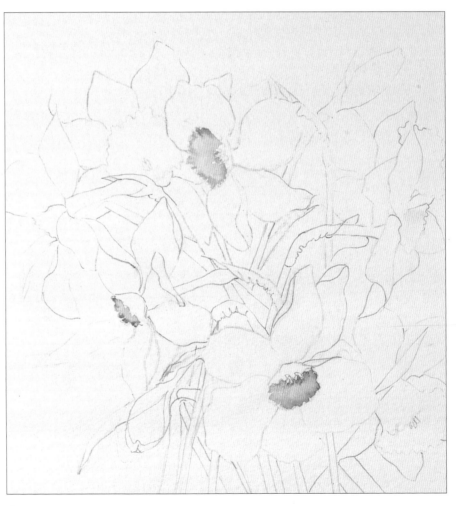

2 Deepen the colour behind the stamens with cadmium orange and soften it with clean water.

3 Repeat the process on the inside of the trumpets of the other jonquils.

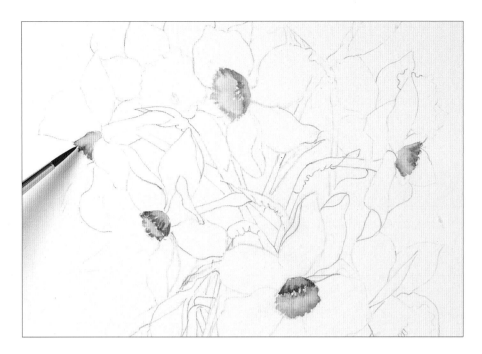

4 Make a slightly richer mix of yellow by adding more quinacridone gold, and add permanent rose to the orange edging mix. Use these mixes to paint the outsides of the trumpets in the same way as the insides.

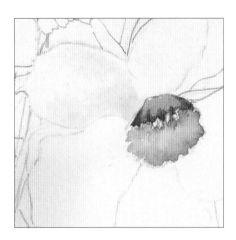

5 Prepare a very dilute grey-blue mix of cobalt blue, cadmium lemon and a touch of indigo. Use this mix for the initial shading of the jonquil's petals. Wet the first petal and drop in the grey-blue mix before drawing it towards the trumpet.

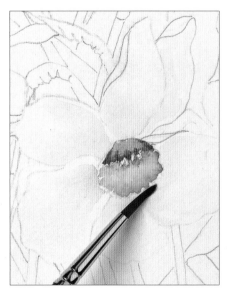

6 Paint the remaining petals of the large central jonquil, remembering to leave a thin white line between the petals to ensure the colours do not bleed across petals. Allow the flower to dry thoroughly.

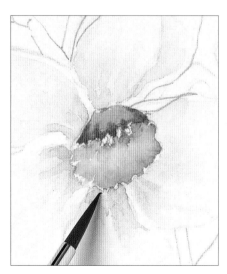

7 Make a stronger grey-blue mix with a touch more blue than previously, and add detail to the petals wet-on-dry, working towards the centre of the flower.

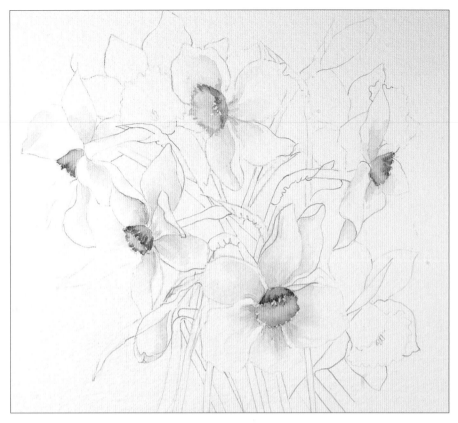

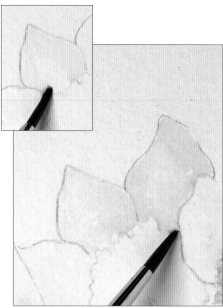

8 Still using the size 4 brush, paint the other jonquils in the same way, remembering to paint the pale mix first and letting it dry completely before applying the darker mix.

9 Make a mix of cadmium lemon with a little quinacridone gold and use this with a size 4 brush to paint the outside petals of the left-hand daffodil in the same way as the petals on the jonquils: paint a thin line round the edge (see inset), then draw it into the centre with water.

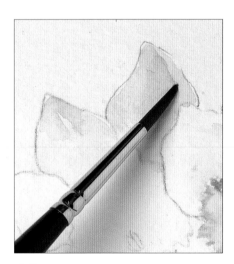

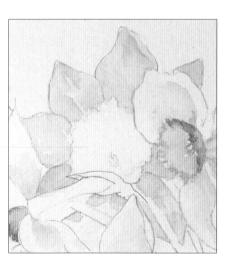

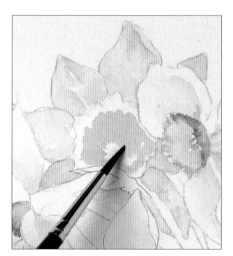

10 Working wet-in-wet, add a touch of cadmium lemon with a tiny amount of indigo to the yellow mix to add modelling and texture.

11 Paint the remaining petals of the daffodil in the same way, being careful to fill in the areas of petal that can be seen past the foreground jonquil.

12 Make a warmer yellow mix with quinacridone gold and cadmium lemon; and prepare a small amount of cadmium orange. Use the size 4 brush with the warm yellow mix to paint the inside of the daffodil's trumpet.

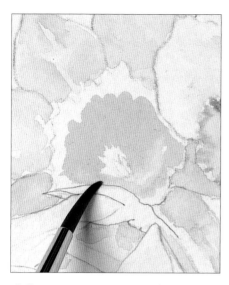

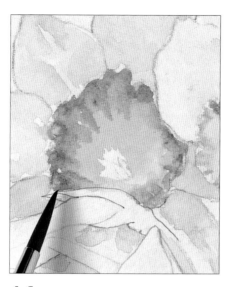

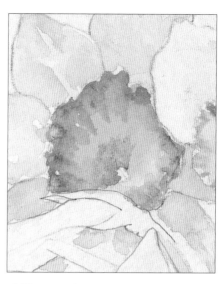

13 Quickly clean and dry your brush, and use it to lift out a highlight in the bottom right of the trumpet as shown.

14 Still working wet-in-wet, add the orange edging to the trumpet in the same way as the jonquils.

15 Make a dark green mix of quinacridone gold and indigo. Add a touch of this mix to the warm yellow and paint the centre of the trumpet to add depth.

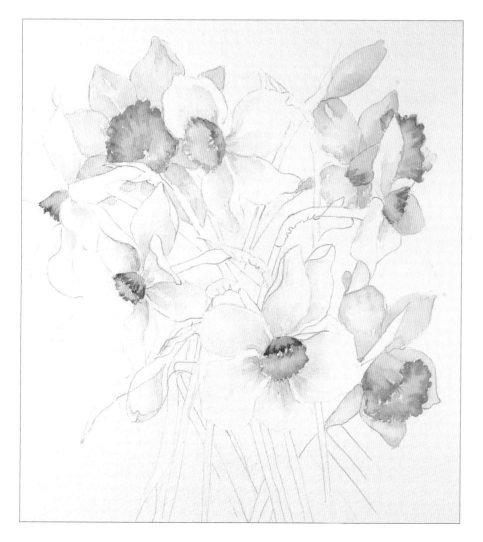

16 Paint the other daffodils in the same way.

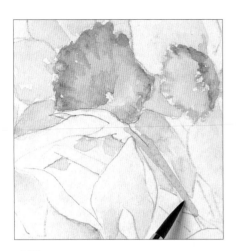

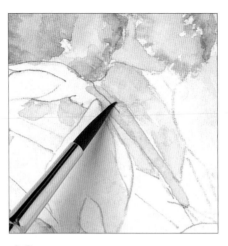

17 Use the pale green mix and the size 4 brush to paint the stem of the daffodil at the top left.

18 Lift out some of the paint with a clean, dry brush to add modelling to the stem.

19 Mix more of the darker green (quinacridone gold and indigo) for shading. Use this to add the shadow on the stem.

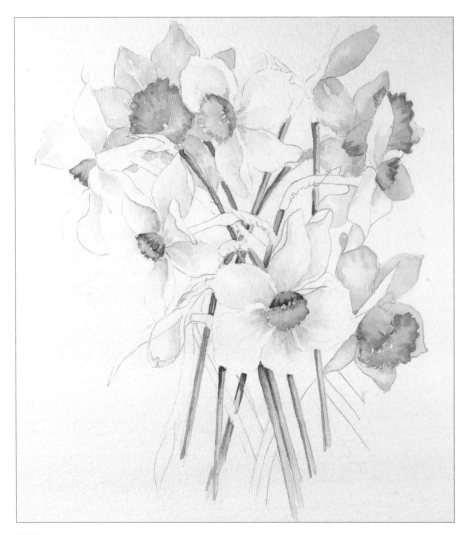

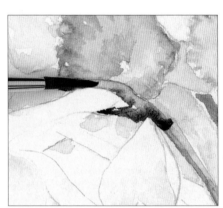

21 Paint the caul of the top left daffodil with a pale mix of brown madder and quinacridone gold. Make a second, stronger mix with more brown madder and some cobalt violet. Use this dark mix to add shading.

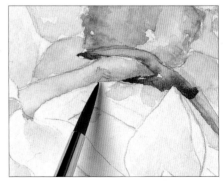

20 Soften the hard edge of the shadow with clean water, then paint the remaining stems. Refer to the finished picture to make sure you are not painting the leaves, as these need to be painted later with a blue-green mix.

22 Paint the part of the stem between the flower and the caul in the same way as the rest of the stem but with a softer shadow.

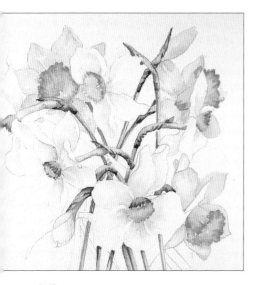

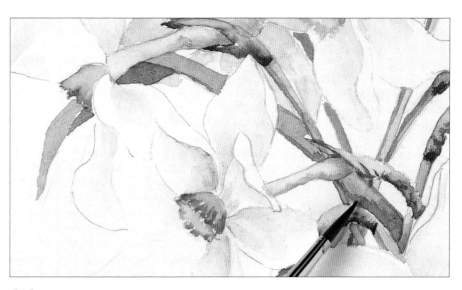

23 Painting the cauls and stems in the same way will now complete the rest of the flowers.

24 Make a blue-green mix of cobalt blue and a slightly smaller amount of cadmium lemon for the cooler sides of the leaves. Paint the leaf at the top left using the size 4 brush. Add indigo and quinacridone to the mix for the shadows.

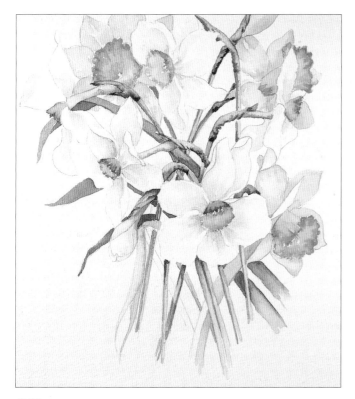

25 Paint the cool parts of the other leaves with the same mixes as shown.

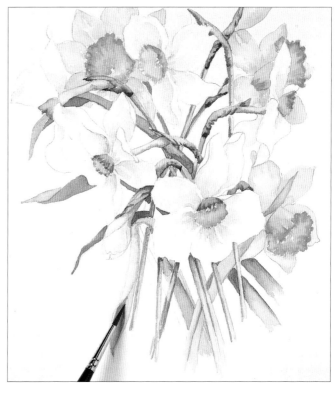

26 Use the blue-green shadow mix to paint the warmer parts of the leaves as pictured, and add a touch more indigo and quinacridone gold for the deepest shadows and recesses of the leaves.

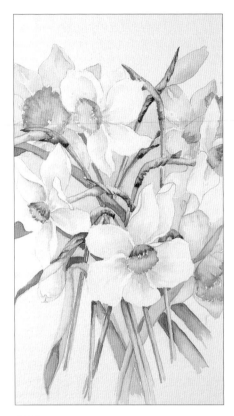

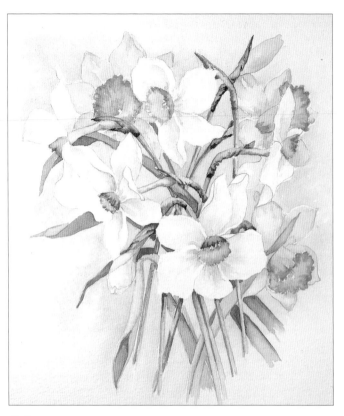

27 Prepare a pale wash of cobalt blue and paint this into all of the enclosed areas of background with the size 4 brush. Allow to dry.

28 Switch to the size 10 brush and, working in small sections, paint the background with water from the edges of the painting to the edges of the paper. Drop the blue wash into the water a little way from the painting and draw the colour towards the flowers.

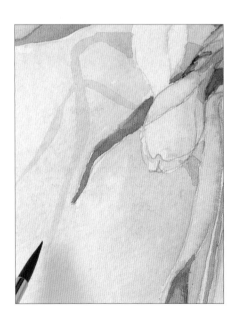

Tip

The extra background stems are not included on the tracings, and so can be placed anywhere. This can help if you have made a small mistake in the painting. A crafty twig or stem at this point can cover a multitude of sins!

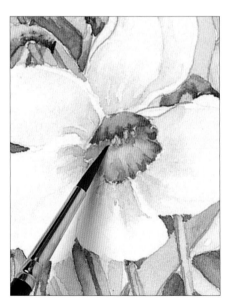

29 Once the background is dry, add extra depth by using a stronger blue wash to add additional leaves and stems in the background.

30 Use cadmium orange to paint the stamens in the trumpets and strengthen the edges of the trumpets to finish.

Opposite

The finished painting. The pencil lines can be gently rubbed away with a clean eraser if you wish.

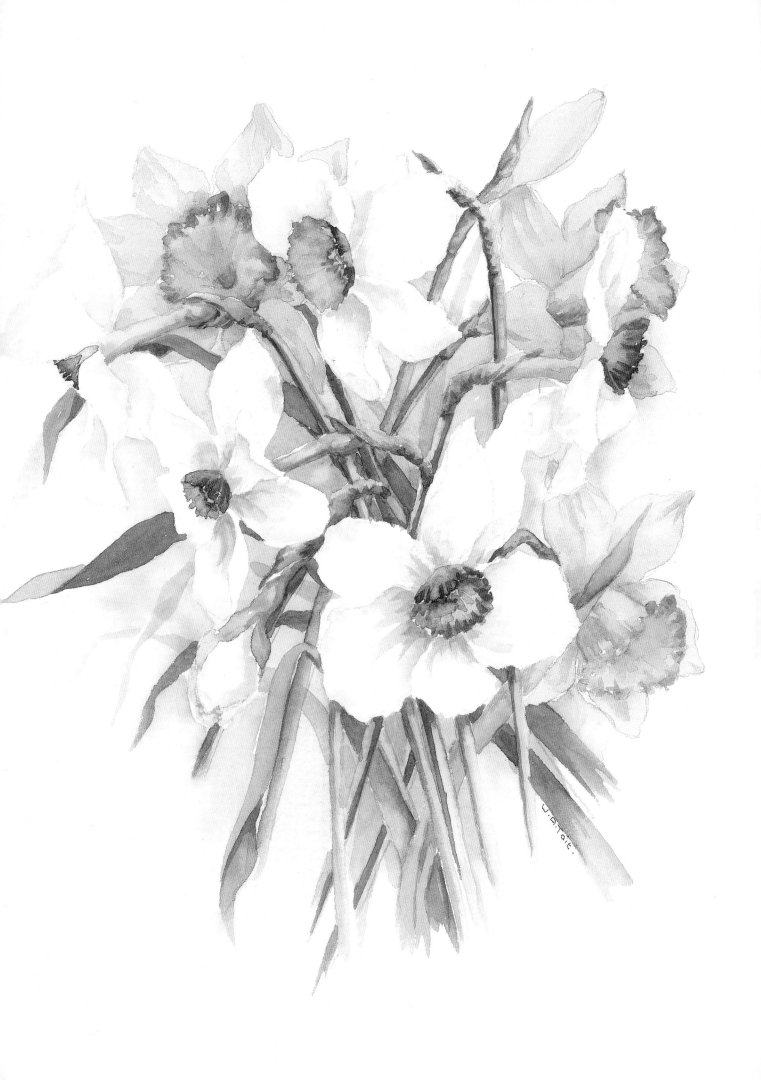

Clematis

The main technique used in this project is called negative painting. This is often used in watercolour when you are painting a lot of foliage because you can not lay light tones on darker tones without losing transparency.

The tiny darks that are put in right at the end have the effect of bringing the lighter colours forward.

You will need

300gsm (140lb) Not finish watercolour paper

Masking tape

Cleaning rag

Board

Colours: cadmium lemon, quinacridone gold, indigo, quinacridone magenta, cobalt blue, cobalt violet, brown madder, permanent rose

Brushes: size 10 round sable mix, size 4 round sable mix, large flat brush

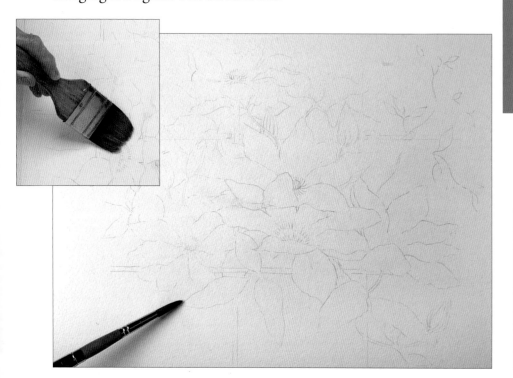

1 Transfer the image to the paper and prepare a mid-green mix of cadmium lemon, quinacridone gold and a touch of indigo; a blue-violet mix of cobalt blue, cobalt violet and a little quinacridone magenta; and a lilac mix of permanent rose and cobalt blue. Wet the whole paper with a large brush (see inset). Charge a size 10 brush with a very thin mix of cadmium lemon and quinacridone gold. Drop this randomly over the paper as shown.

2 Working wet-in-wet, work very thin drops of the mid-green in amongst the yellow areas, roughly where the leaves will be. Refer to the finished painting if you are unsure.

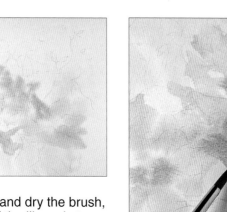

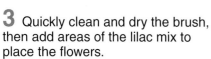
3 Quickly clean and dry the brush, then add areas of the lilac mix to place the flowers.

Tip

While the paper remains wet, you can use a tissue to blot any areas where the paint flows out of place.

4 Still working wet-in-wet, drop a little of the blue-violet mix into the centre of the flowers. Allow the painting to dry completely.

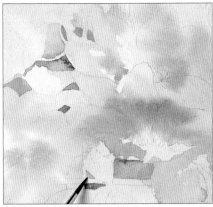

5 Add indigo to your mid-green mix to make a darker green, and use a strong wash of this colour to begin picking out the mid-tone shadows between the leaves and petals, using the size 4 brush.

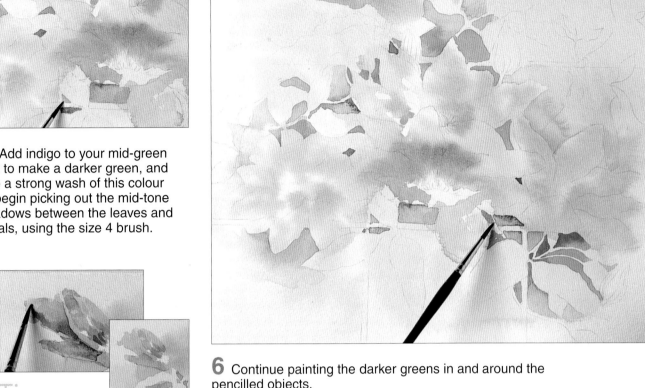

6 Continue painting the darker greens in and around the pencilled objects.

Tip

If the paint dries in an inconvenient or ugly shape (see inset), reshape it by modelling it into a new petal or leaf as appropriate, using darker shades of the original mix.

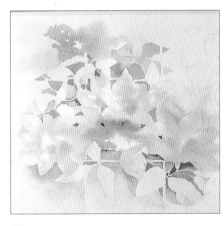

7 Use thicker washes in the centre and gradually add more water to the paint as you get closer to the edges of the painting, so that the centre of the painting has the most impact.

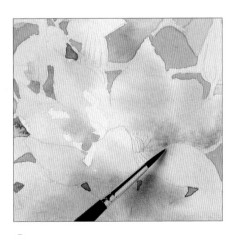

8 Begin to add shading to the upper central flower, using the size 4 brush to wet the petal on the right, then adding the lilac wash.

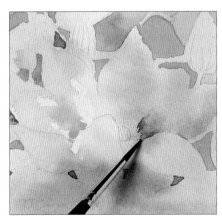

9 Pick out the stamens by adding strokes of a deeper lilac tone towards the centre of the flower.

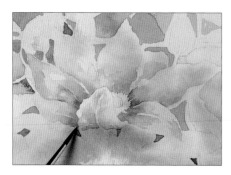

10 Detail all of the other petals of the flower in the same way. Do not cover the entirety of each petal: the colour of the initial wash should remain dominant.

11 Bring out the detail of the other flowers in this way, using slightly stronger mixes for the lower central flower to show that it is partially shaded by the upper central flower. Add further modelling by painting the mix on dry areas and softening with clean water.

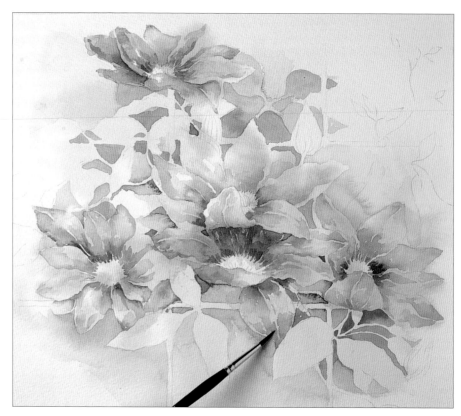

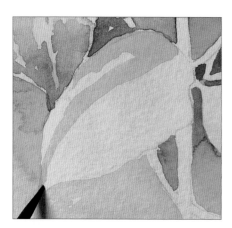

12 Using a thin wash of mid-green with the size 4 brush, paint a shadow on to the side of one of the leaves.

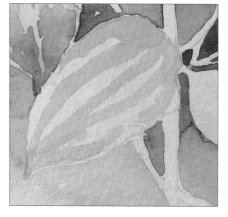

13 Draw a series of stripes across the leaf with the same mix.

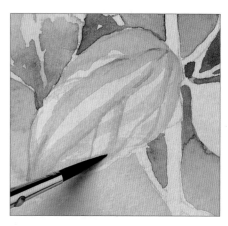

14 Use a dryer, stronger mix of mid-green to draw fine lines down the stripes with the tip of the brush.

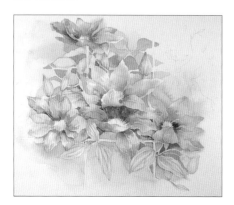

15 Model the other large leaves and buds in the same way.

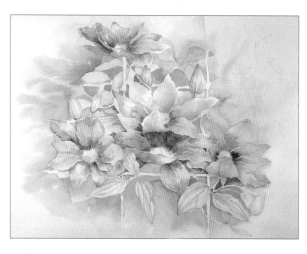

16 Use the size 10 brush and make up some more of the initial mixes. Wet the remaining white paper and paint in thin variegated washes in the background, overlapping the existing background, making the tone deeper behind the flowers.

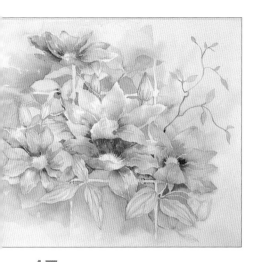

17 Paint the tendrils on the top right using the size 4 brush with mid-green. Shade it with brown madder wet-in-wet, then paint the other tendrils in the same way.

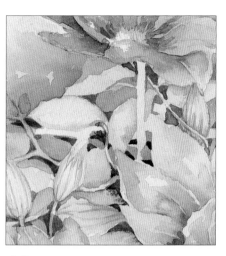

18 Start to define the foliage by painting in small areas using a very dark green mix and the size 4 brush. This stage can be used to adjust the painting, covering up minor mistakes and reinforcing the shape of the picture.

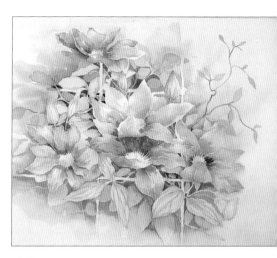

19 Complete the negative painting of the foliage, using progressively lighter tones towards the edge of the paper.

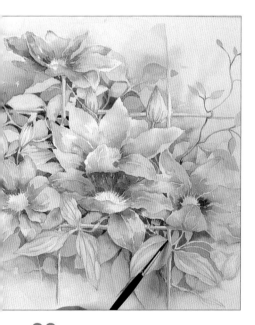

20 Use the blue-violet to paint the two emerging clematis flowers on the upper left and to paint the shading on the trellis.

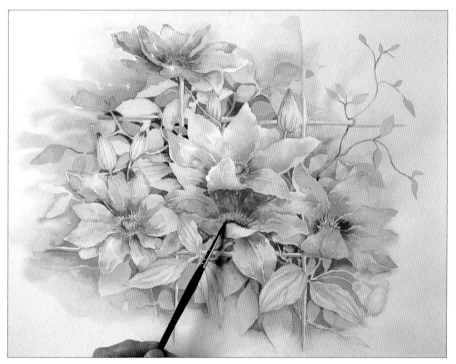

21 Use the mid-yellow to paint the centres of the flowers. Once dry, detail the centres with a mix of brown madder and cobalt violet. Lay a very thin glaze of blue-violet over the centres of the flowers at the top and lower centre, as these are in shade.

Overleaf
The finished painting

Note how the tiny dark tones just behind the central flowers directs the eye to the focal point.

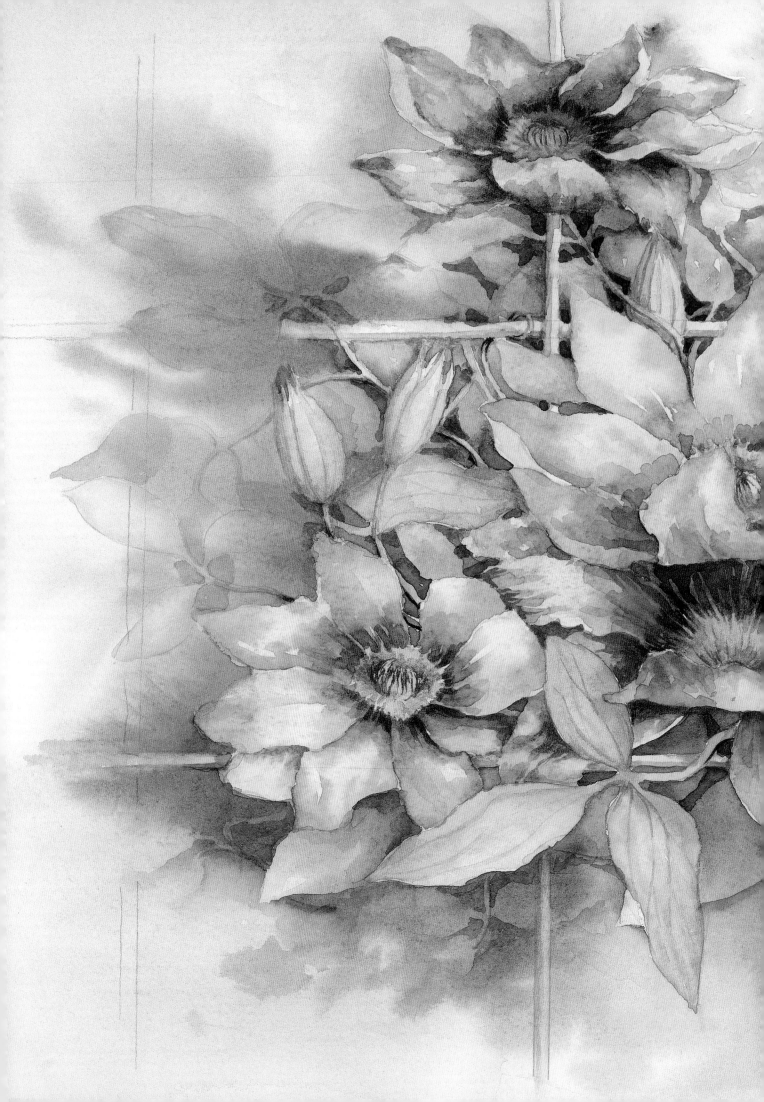

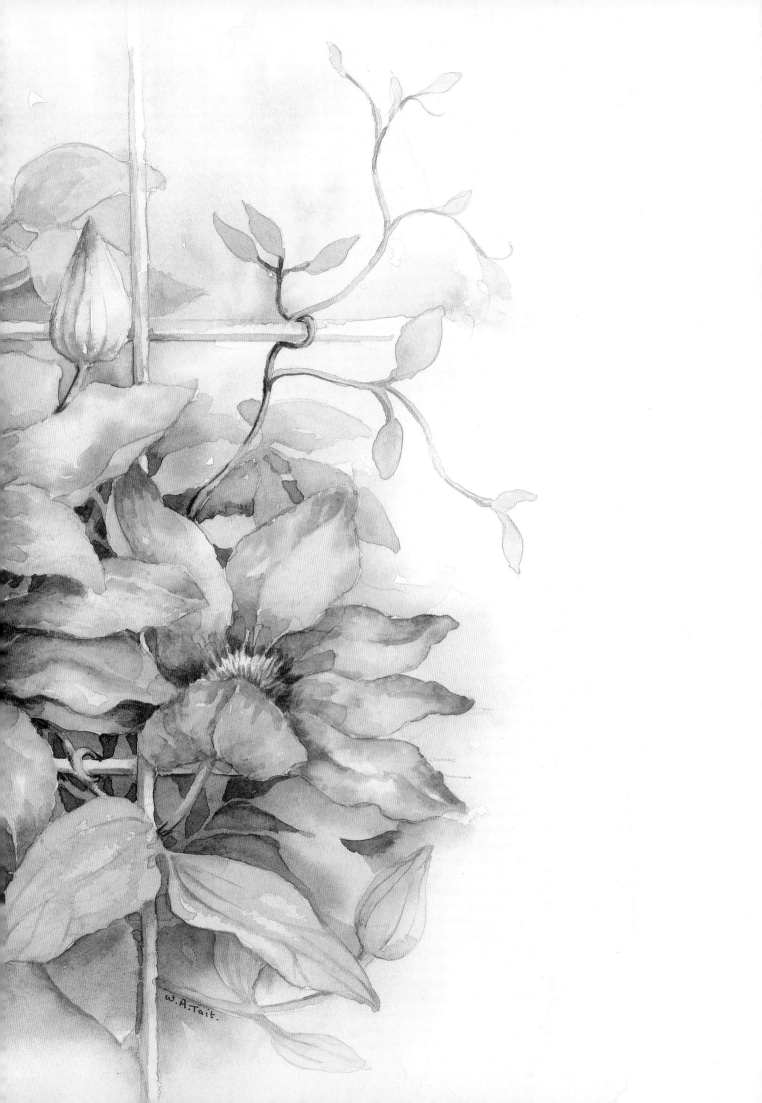

W.A.Tait.

Index

background 7, 15, 23, 31, 34, 40, 44
board 8, 10, 18, 26, 32, 34
brushes 7
 large flat 7, 42
 size 4 round 7, 10, 12, 13, 18, 21, 25, 26, 27, 28, 32, 34, 36, 38, 40, 42, 43, 44, 45
 size 10 round 7, 10, 14, 18, 24, 26, 31, 34, 40, 42, 44
buds 13, 14, 16, 22, 23, 44
burnishing tool 8, 9

caul 38, 39
clematis 45
colour palette for flowers 6
control of the brush 14

daffodils 34, 36, 37, 38
daisies 9, 14, 15
definition 15
details 16, 22, 29, 32, 35, 44
dry brush 8, 11, 38

focal point 32, 45
foliage 30, 31, 32, 42, 45
foreground 36
freshness 15, 24

glazing 16, 20, 24, 45

highlights 11, 18, 19, 30, 37

jonquils 34, 35, 36, 37

leaves 21, 22, 23, 29, 30, 32, 38, 39, 40, 42, 43, 44
 variegated 30
lifting out 11, 19, 24, 37, 38

masking tape 8, 10, 18, 24, 26, 34, 42
modelling 15, 28, 29, 36, 38, 43, 44

negative painting 42, 45

paints 6, 8
pansies 26, 27, 28, 29, 30, 32
paper 7, 8, 9, 10, 14, 18, 26, 30, 30, 31, 34, 40, 42
pencil 8, 9, 24, 28, 40
petals 10, 11, 12, 16, 18, 19, 20, 27, 28, 29, 35, 36, 43, 44
poppies 9, 10, 11, 14, 16
primroses 26, 27, 29, 30, 32

roses 18, 19, 20, 24

scrap paper 9
shading 11, 15, 18, 20, 21, 22, 23, 29, 30, 38, 43, 45
shadows 11, 13, 15, 22, 26, 28, 30, 32, 38, 39, 43, 44
spoon 8, 9

stamens 12, 19, 20, 34, 40, 43
stems 12, 13, 14, 22, 23, 30, 32, 38, 39, 40
stippling 20
softening 13, 15, 22, 26, 34, 38, 44

tone 10, 21, 26, 28, 30, 32, 42, 44, 45
 cool 24, 39
 warm 21, 24, 39
transferring the image 8, 9, 10, 18, 26, 34, 42
trumpet 34, 35, 36, 37, 40

wet-in-wet 7, 15, 19, 21, 27, 29, 31, 36, 37, 42, 45
wet-on-dry 23, 35

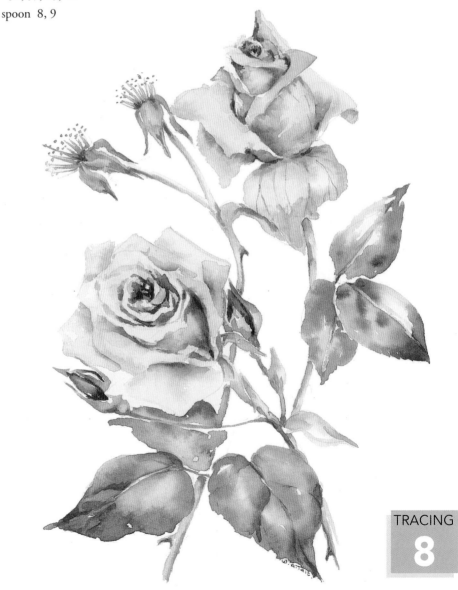

TRACING
8